Sarnia Ontario Book 4 in Colour Photos, Saving Our History One Photo at a Time

Photography
by Barbara Raué
2015

Series Name:
Cruising Ontario

Book 136: Sarnia Book 4

Cover photo: 262 Vidal Street North, Page 20

Series Name: Cruising Ontario
Saving Our History One Photo at a Time
in colour photos

Books Available in Alphabetical Order:
Aberfoyle, Acton, Alton, Ancaster, Arthur, Aylmer, Ayr, Bloomingdale, Brantford, Burlington, Caledon, Caledonia, Cambridge, Clifford, Conestogo, Delhi, Dorchester to Aylmer, Drayton, Drumbo, Dundas, Eden Mills, Elmira, Elora, Fergus, Guelph, Hagersville, Hamilton, Hanover, Harriston, Hespeler, Jarvis, Kitchener, Linwood, Listowel, London, Lucknow, Mono, Mount Forest, Neustadt, New Hamburg, Niagara-on-the-Lake, Oakville, Orangeville, Orillia, Owen Sound, Palmerston, Peterborough, Port Elgin, Preston, Rockwood, Seaforth, Sheffield, Shelburne, Simcoe, Southampton, St. Jacobs, St. Thomas, Stoney Creek, Stratford, Tillsonburg, Waterdown, Waterrford, Waterloo, Wellesley, Wingham

Book 110:Lucknow,Mitchell
Book 111: Conestogo, Bloomingdale
Book 112: Delhi
Book 113: Waterford
Book 114-116: Waterloo
Book 117-119: Windsor
Book 120-121: Amherstburg
Book 122: Essex
Book 123-124: Kingsville
Book 125-127: Woodstock
Book 128: Thamesford
Book 129-132: St. Mary's
Book 133-136: Sarnia

Other Books by Barbara Raue

Coins of Gold

Arrows, Indians and Love

The Life and Times of Barbara
Volume 1: Inventions That Have Enhanced My Life
Volume 2: Entertainment That I Have Enjoyed
Volume 3: East Coast Trips
Volume 4: Olympics Have Always Intrigued Me
Volume 5: Wonders of the World
Volume 6: Caribbean Cruises We Have Enjoyed
Volume 7: Animals
Volume 8: Storms and Other Major Disasters in My Lifetime
Volume 9: Wars, Terrorist Attacks and Major Disasters

The Cromwell Family Book

Laura Secord Discovered

Daddy Where Are You?

Visit Barbara's website to view all of her books
http://barbararaue.ca

Sarnia is a city in Southwestern Ontario located on the eastern bank of the junction between the Upper and Lower Great Lakes where Lake Huron flows into the St. Clair River, which forms the Canada-United States border, directly across from Port Huron, Michigan.. It is the largest city on Lake Huron. The city's natural harbor first attracted the French explorer LaSalle, who named the site "The Rapids" when he had horses and men pull his forty-five-ton barque "Le Griffon" up the almost four-knot current of the St. Clair River in August 1679.

The Blue Water Bridge links Sarnia and its neighboring village of Point Edward, Ontario to the city of Port Huron, Michigan in the United States. It spans the St. Clair River, which connects Lake Huron to Lake St. Clair. The bridge's original three-lane span, opened in 1938, was twinned on July 22, 1997, making the bridge the fourth busiest border crossing in Ontario. The Blue Water Bridge links Highway 402 with the American Interstate 94 and 69.

Sarnia's grain elevator, the sixth largest currently operating in Canada, was built after the dredging of Sarnia Harbor in 1927. Within two years, grain shipments had become an important part of Sarnia's economy. The grain elevator rises above the harbor, and next to it is the slip for the numerous bulk carriers and other ships that are part of the shipping industry that includes vessels from all over the world. The waterway between Detroit and Sarnia is one of the world's busiest, with an average of 78,943,900 tons of shipping that annually travelled the river during the period 1993–2002.

Table of Contents

Victoria Street	Page 6
Vidal Street North	Page 8
Vidal Street South	Page 25
Water Street	Page 32
Watson Street	Page 32
Wellington Street	Page 35
Point Edward, Ontario	Page 39
Blue Water Bridge	Page 46
Port Huron, Michigan, U.S.A.	Page 50
Architectural Terms	Page 52
Building Styles	Page 65

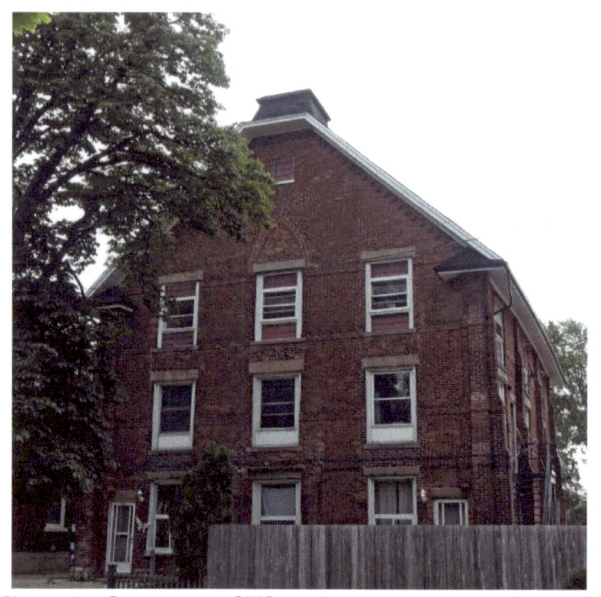

134 Victoria Street – 1879 – Congregationalist Church
Dentil moulding

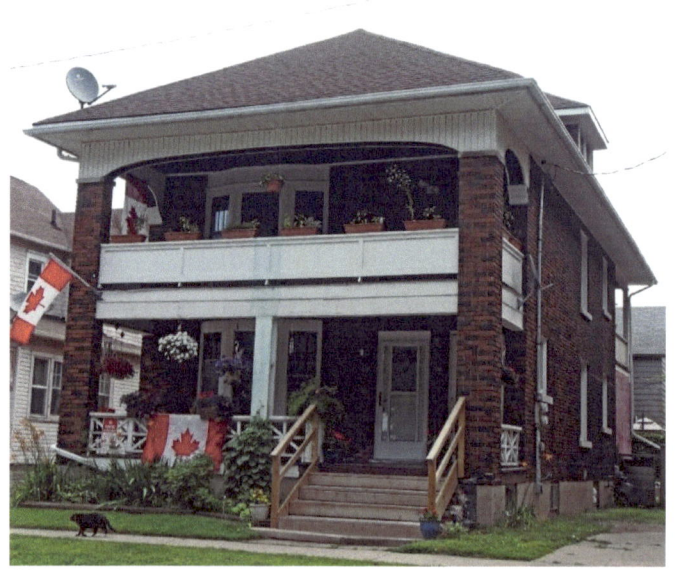

132 Victoria Street – two-storey verandah, dormer

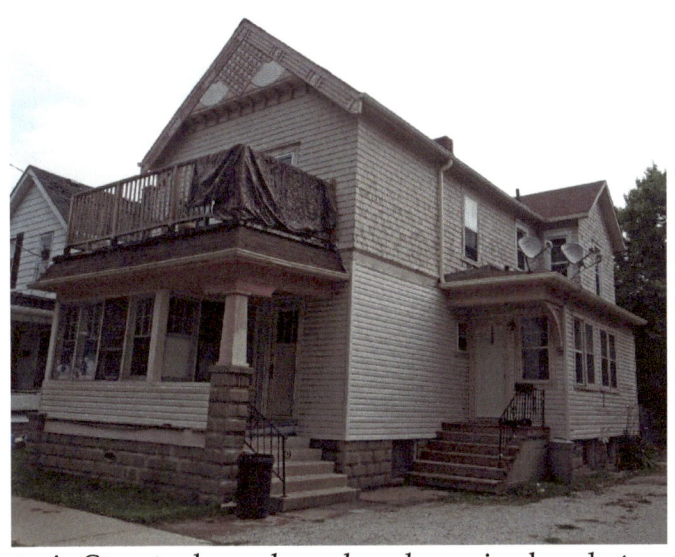

128 Victoria Street – bargeboard and cornice brackets on gable

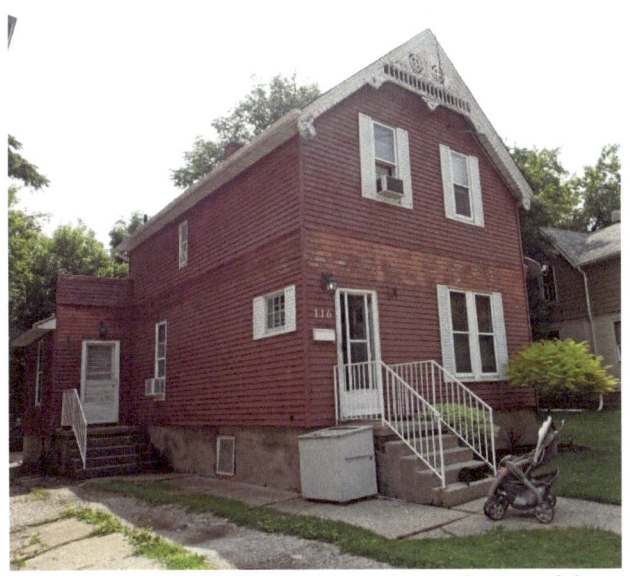

116 Victoria Street - bargeboard on gable

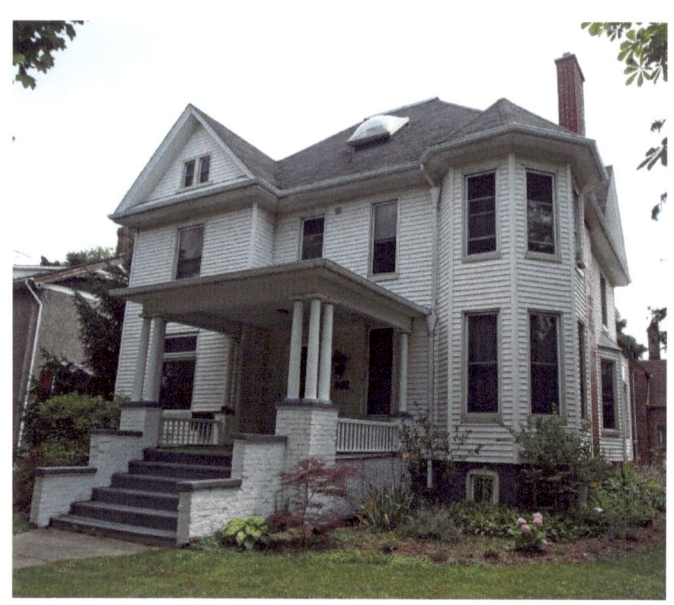

302 Vidal Street North - Edwardian

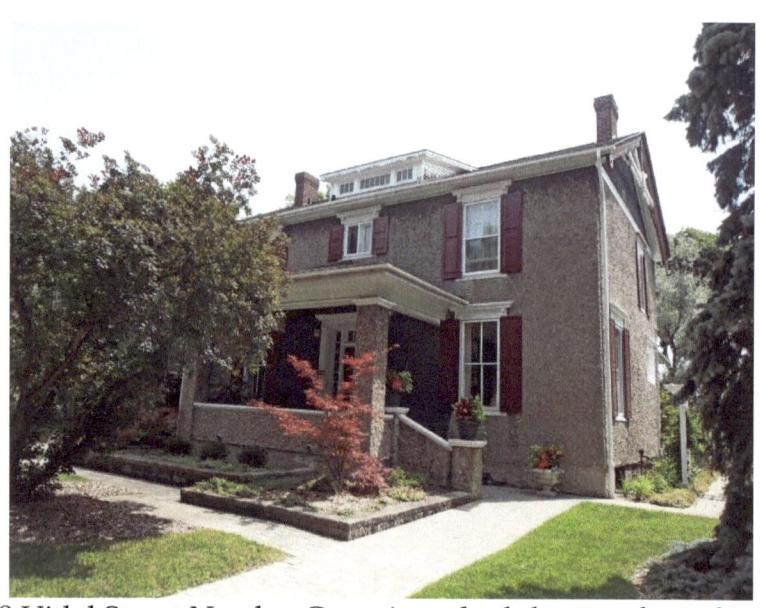

308 Vidal Street North – Georgian, shed dormer, bargeboard on end gable

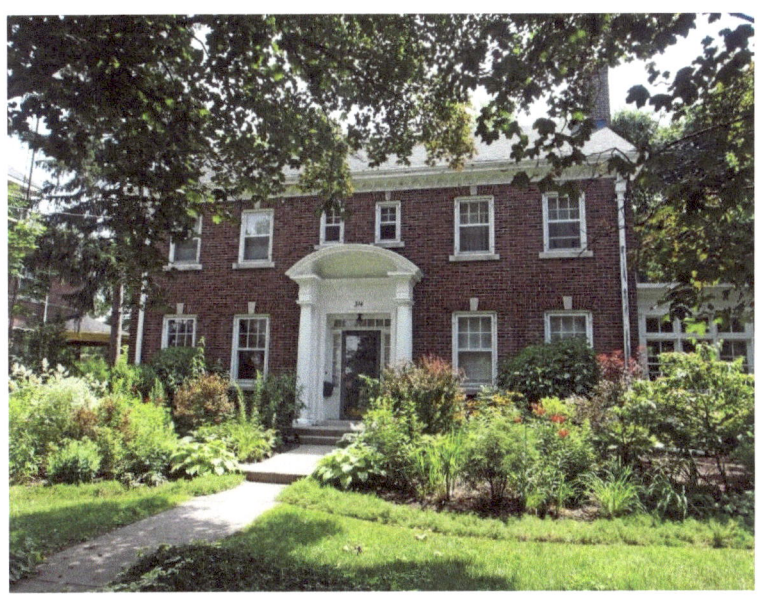

314 Vidal Street North – Georgian, pillared entrance with curved pediment, dentil moulding, decorative cornice, voussoirs and keystones, sidelights and transom window

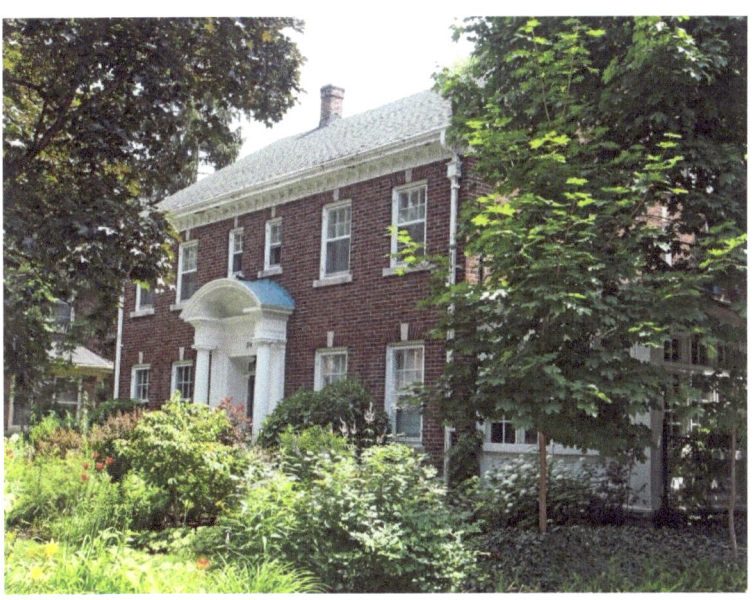

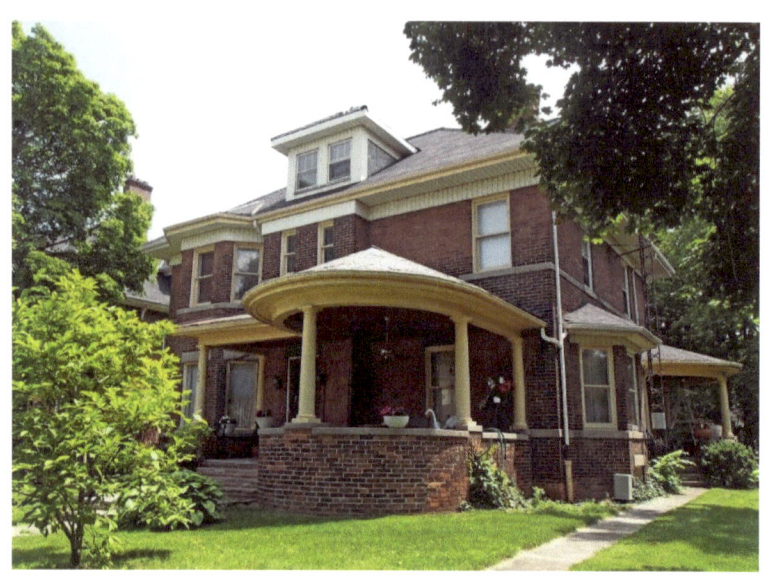

320 Vidal Street North – Queen Anne Revival – 1906
Curved verandah, bay windows, dormer

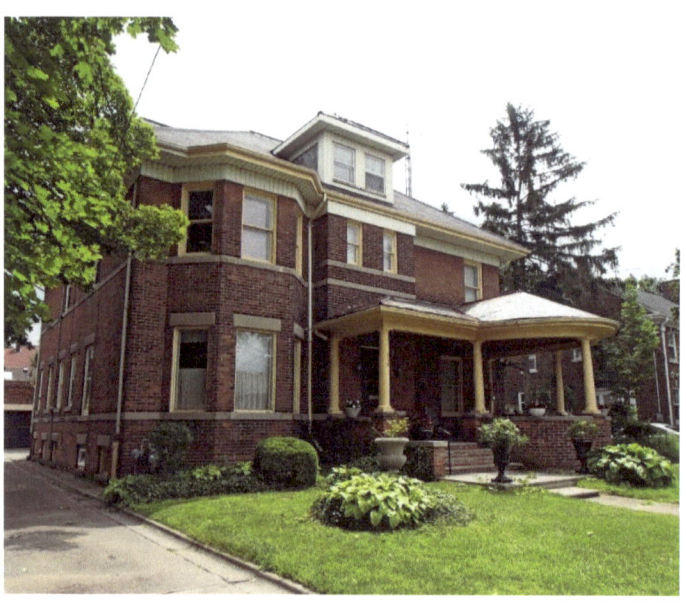

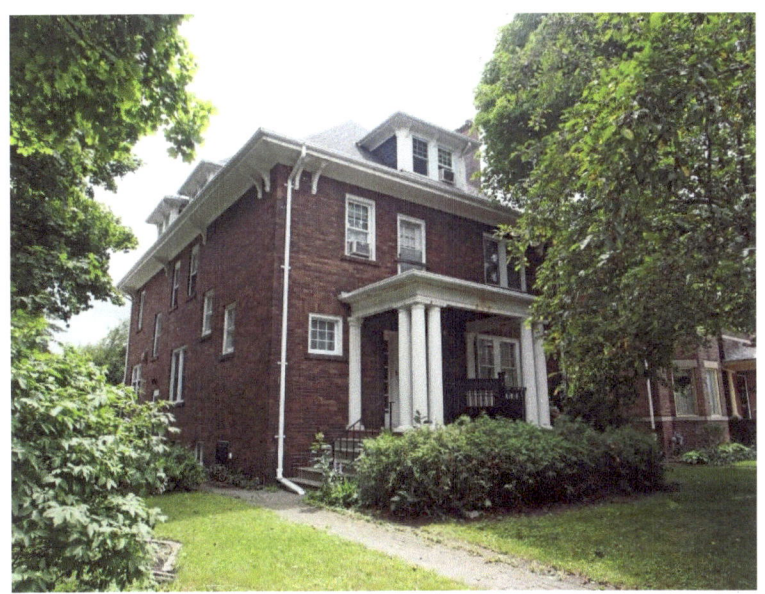

Vidal Street North – Italianate, dormers, cornice brackets

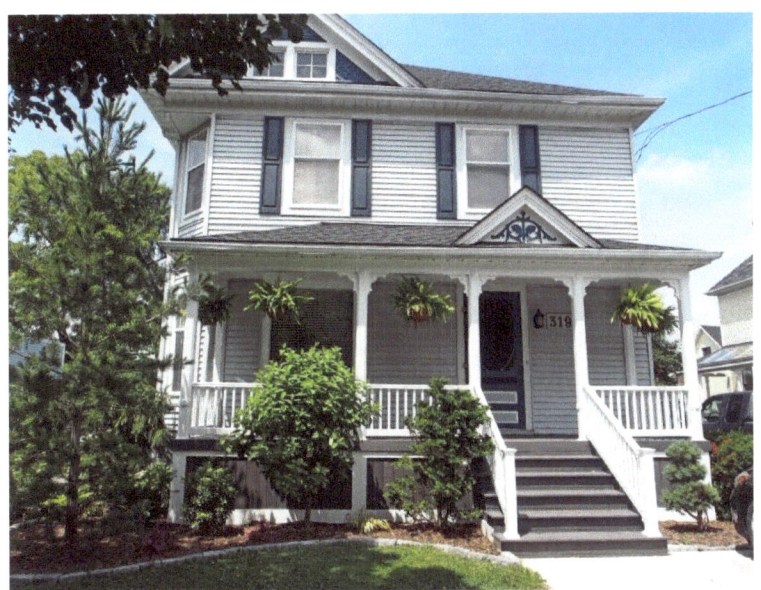

319 Vidal Street North – 1900 – pediment with decorated tympanum

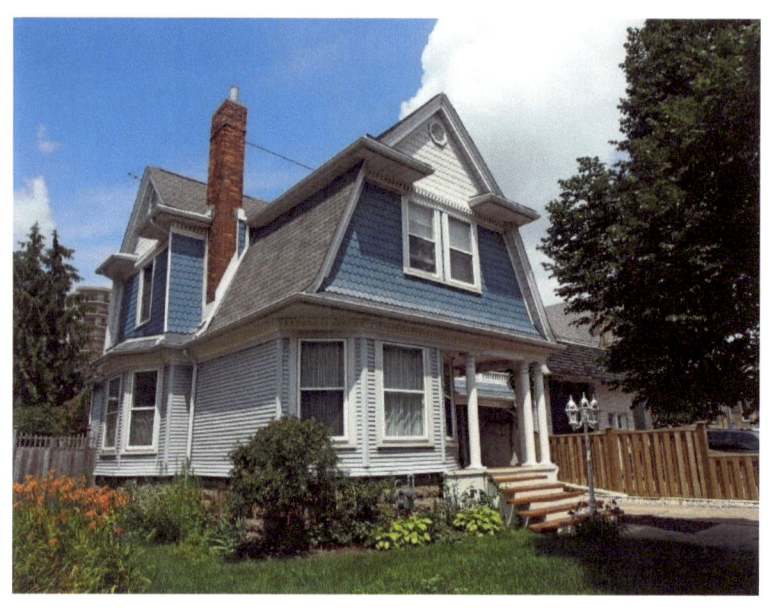

329 Vidal Street North – vernacular, cornice return on gable, wide cornice overhang, fish scale patterning, dentil moulding

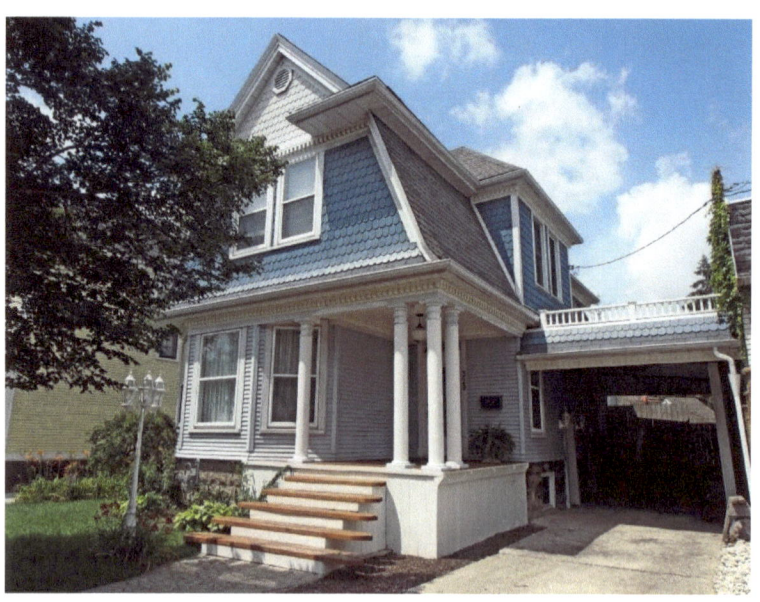

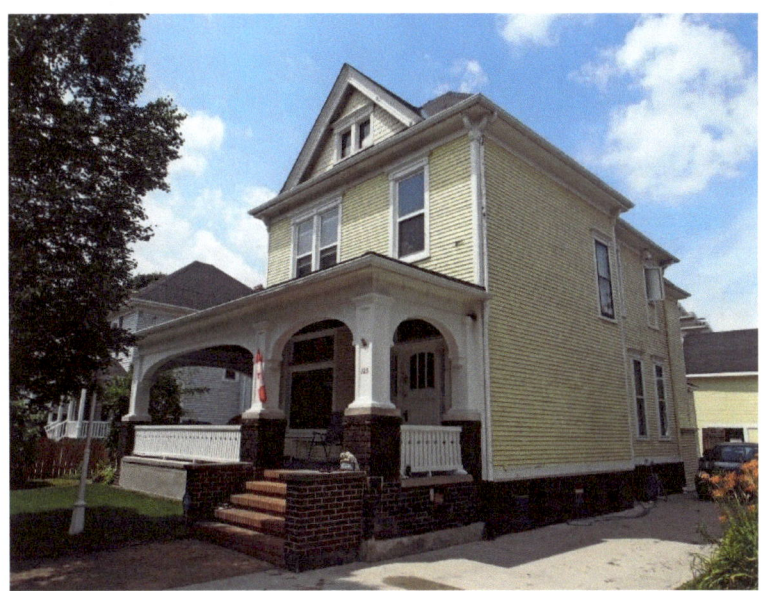

325 Vidal Street North - 1910

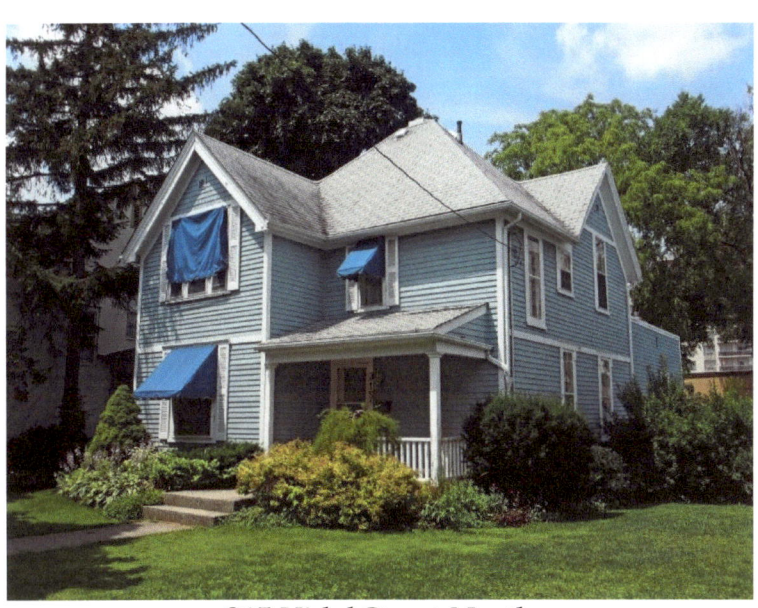

315 Vidal Street North

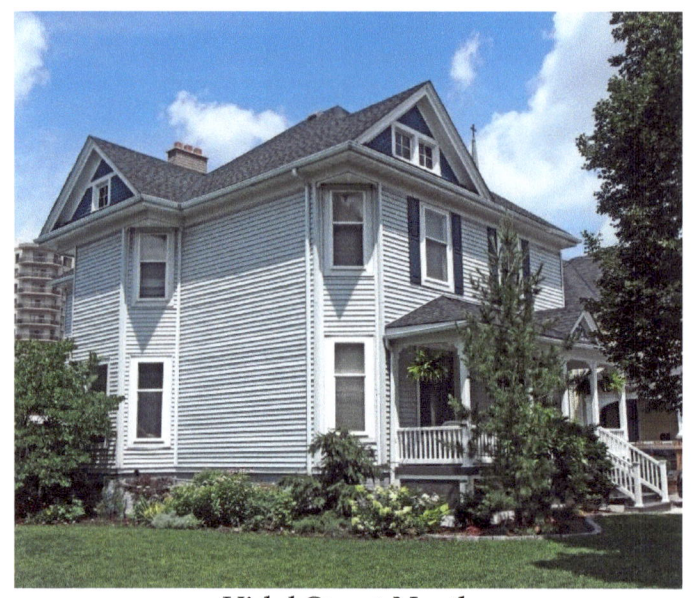

Vidal Street North

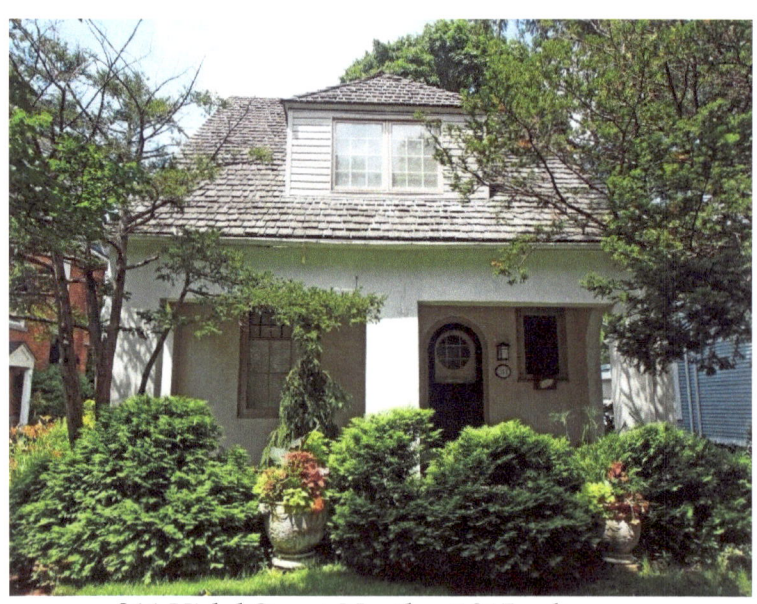

311 Vidal Street North – 1915 - dormer

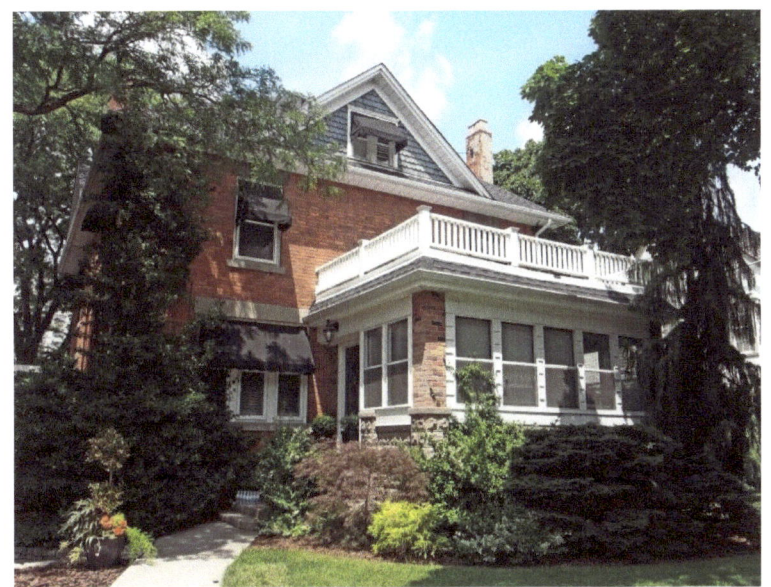

Vidal Street North – balcony above enclosed porch addition

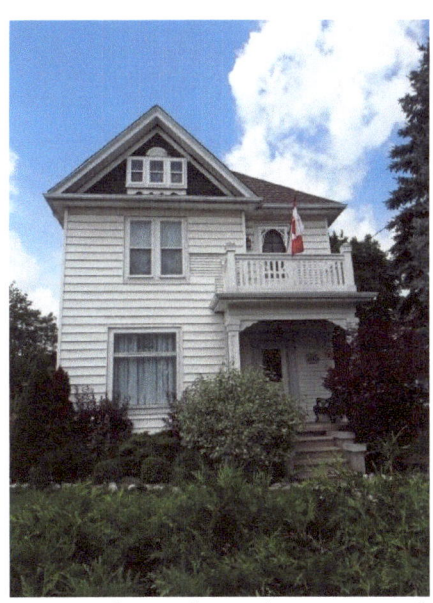

285 Vidal Street North – Edwardian, second floor balcony

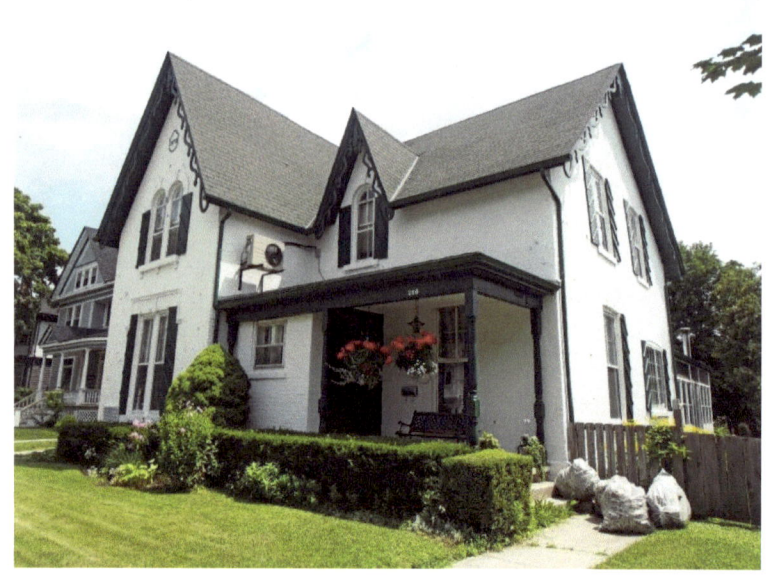

280 Vidal Street North – 1872 – Gothic Revival, verge board trim on gables, voussoirs with keystones

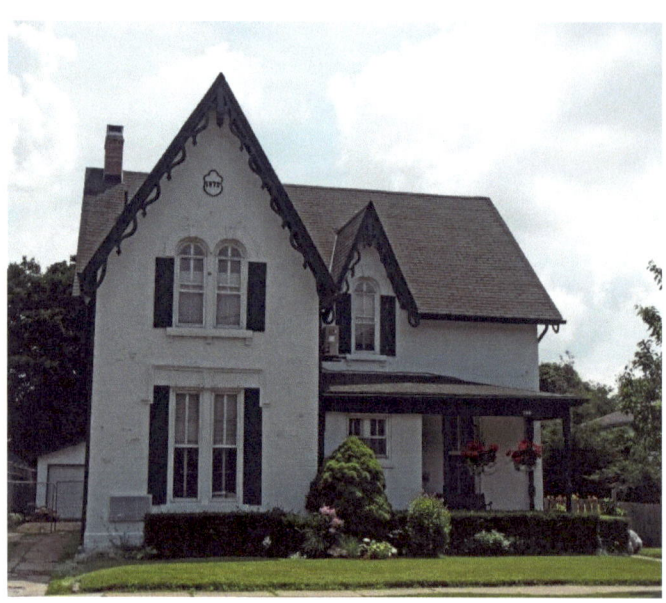

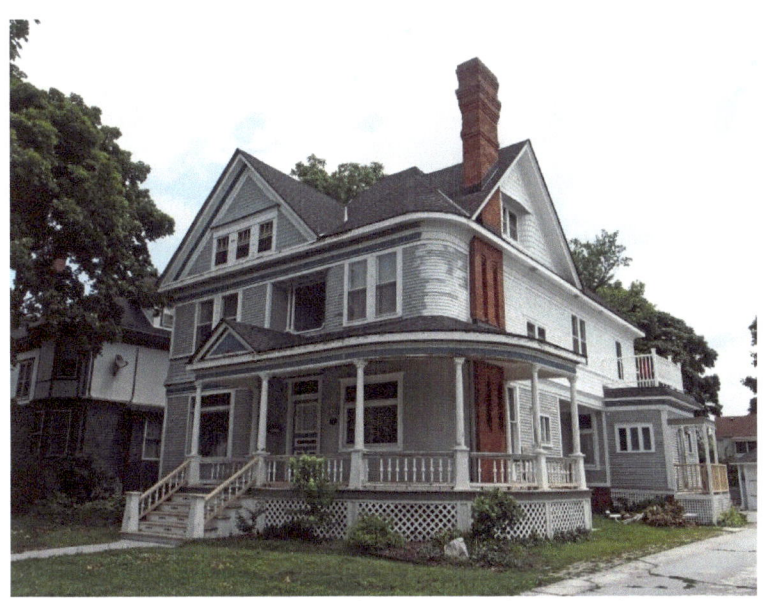

286 Vidal Street North – Edwardian, pediment

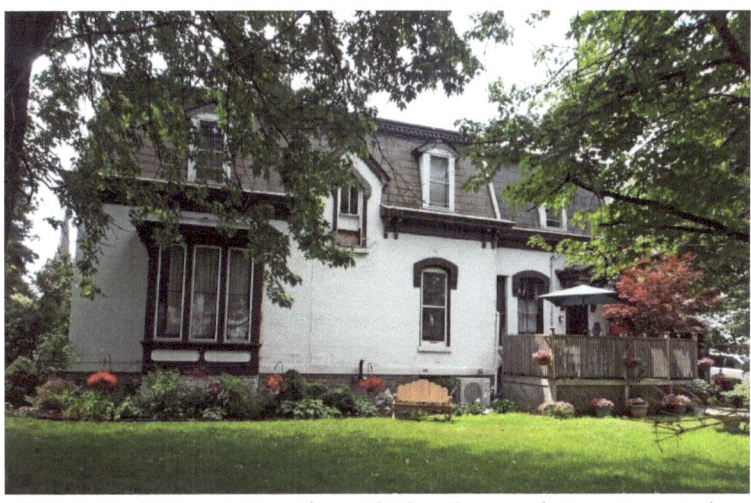

289 Vidal Street North – 1870 – Second Empire style, Mansard roof with dormers, cornice brackets, dentil moulding, rectangular bay window, voussoirs

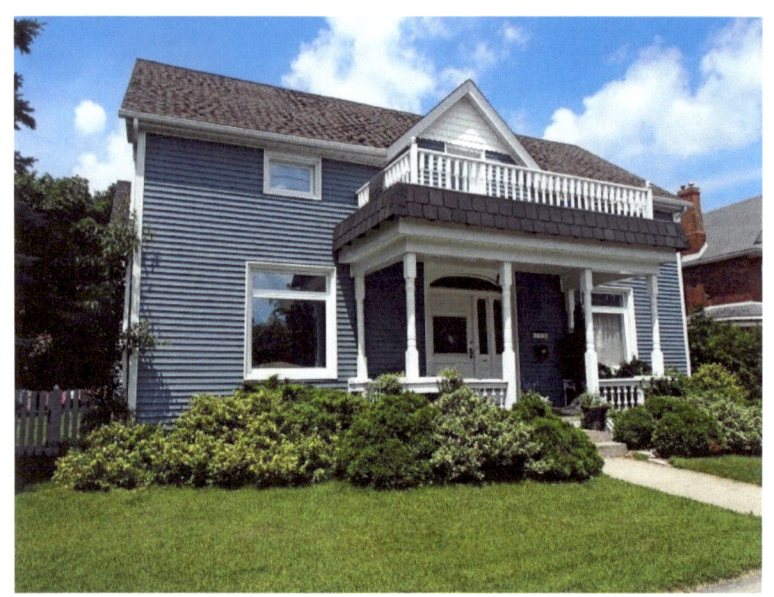

273 Vidal Street North – second floor balcony

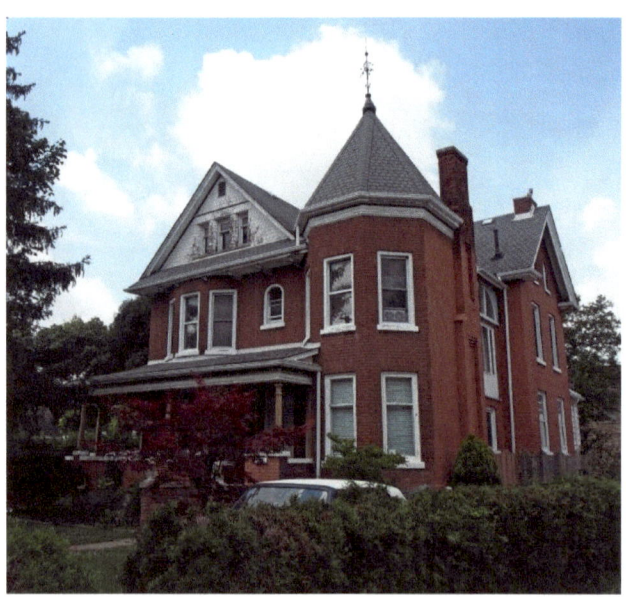

279 Vidal Street North – Edwardian – 1900
– two-storey tower with cone-shaped cap

267 Vidal Street North – bric-a-brac on verandah

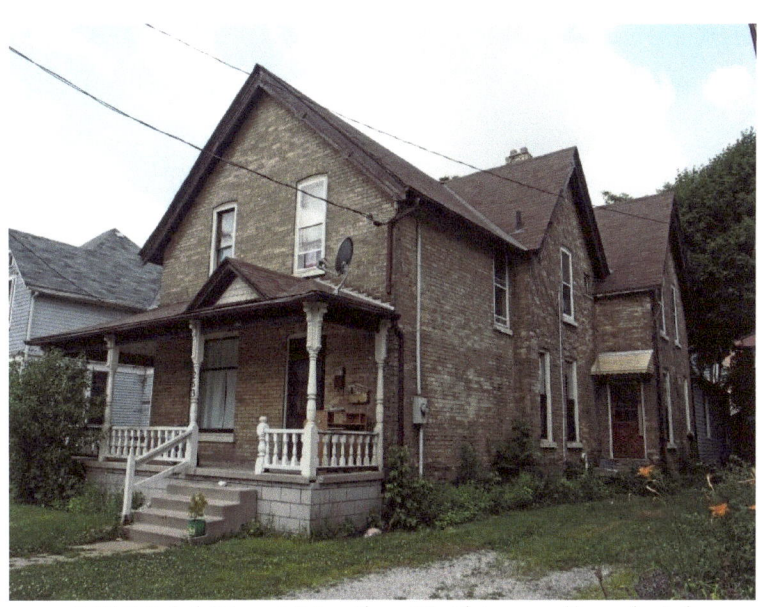

263 Vidal Street North – Gothic - yellow brick

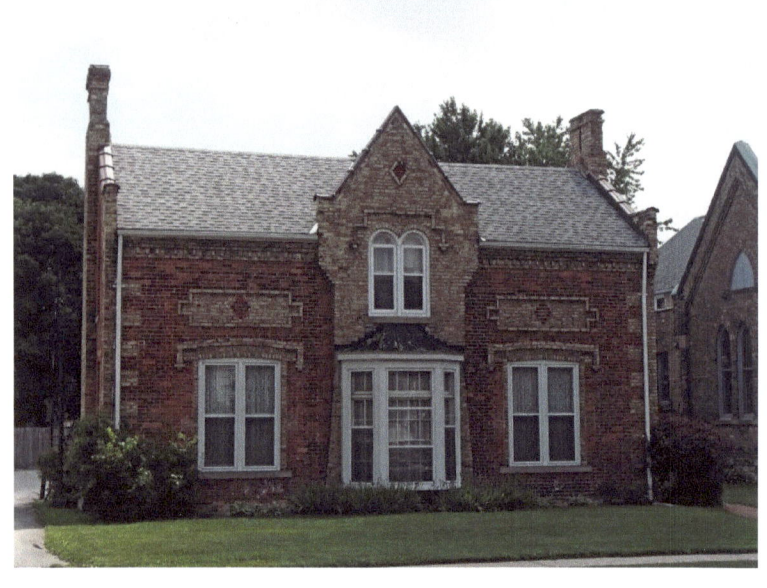

262 Vidal Street North – 1880 – French Canadian home – red and yellow brick detailing, gabled parapets, French bay window

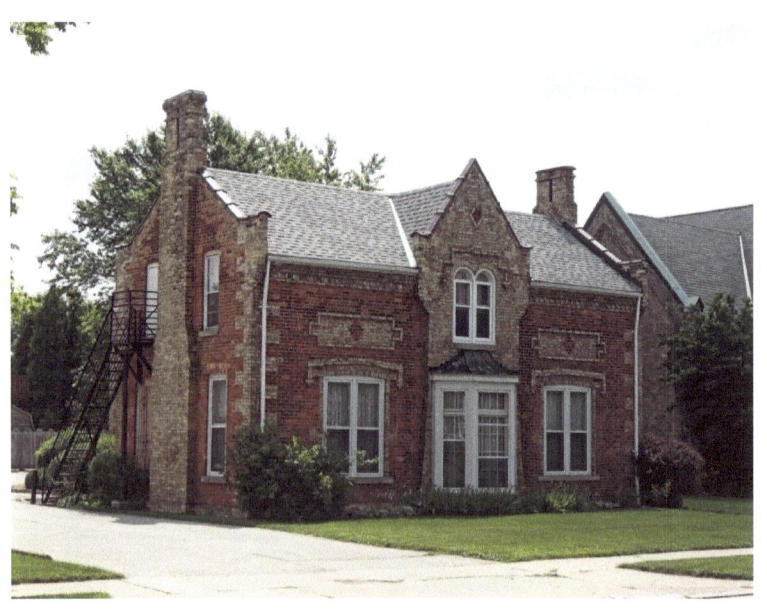

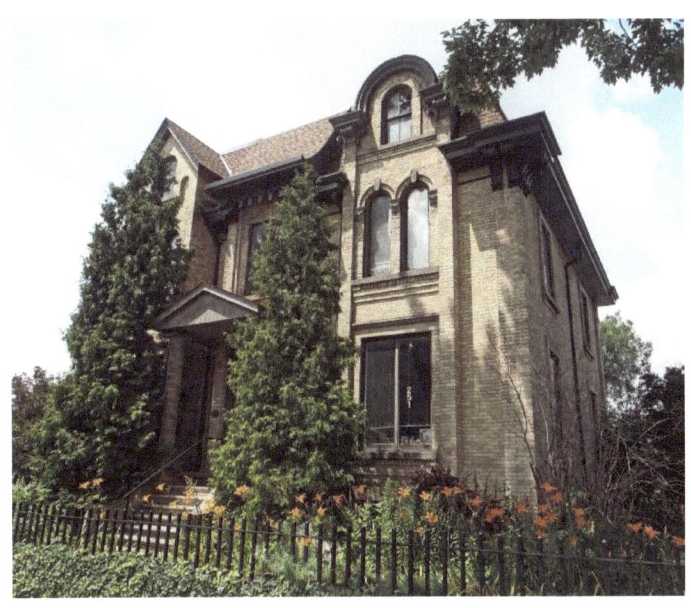

251 Vidal Street North – late 1870s – Christian Science Church – bell-cast mansard roof – Second Empire style, vousoirs and keystones, cornice brackets

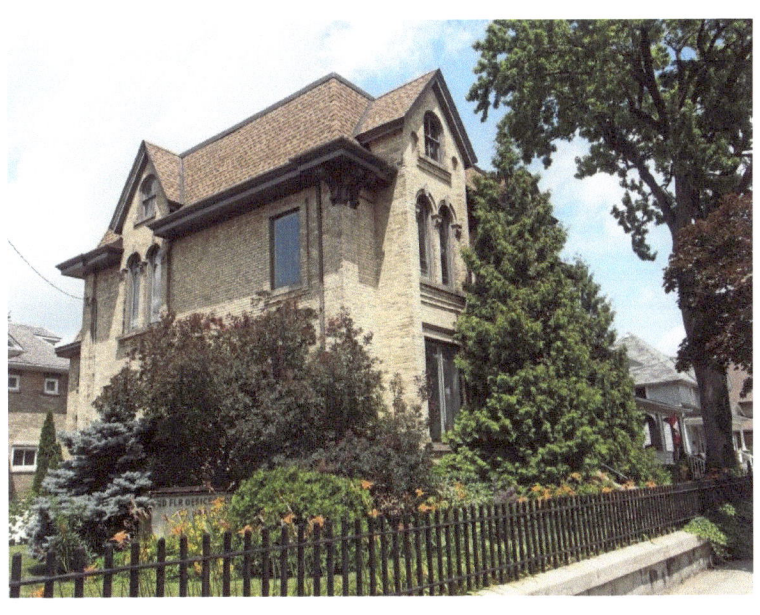

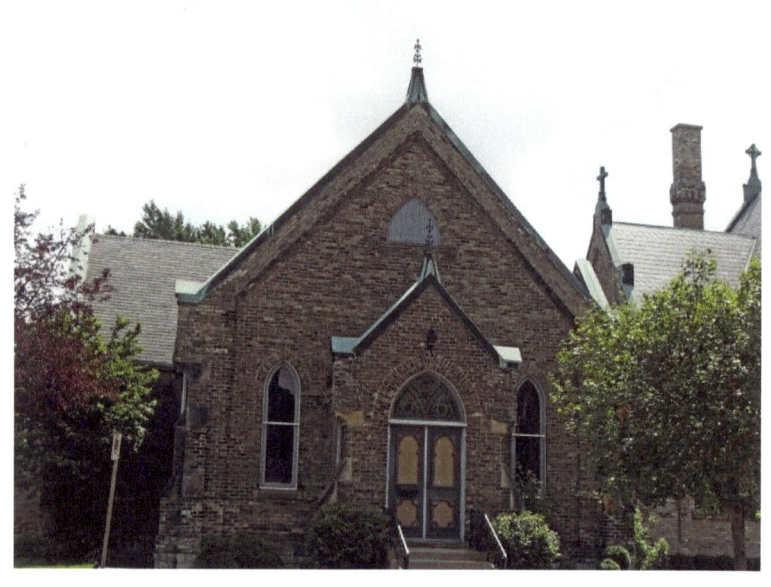

248 Vidal Street North – St. George's All Saints Anglican Church – 1883 – Gothic Revival, lancet windows, banding

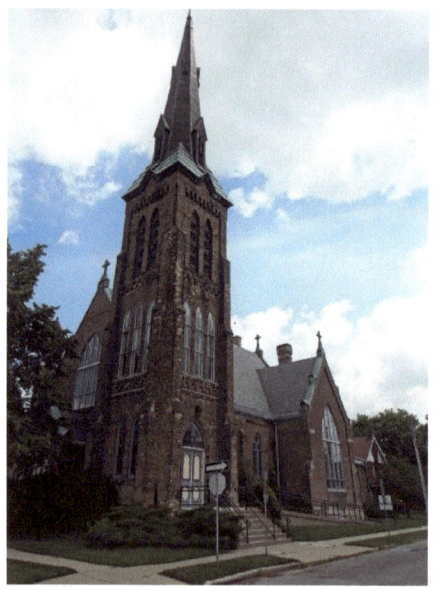

Buttresses

257 Vidal Street North – Gothic - pediment

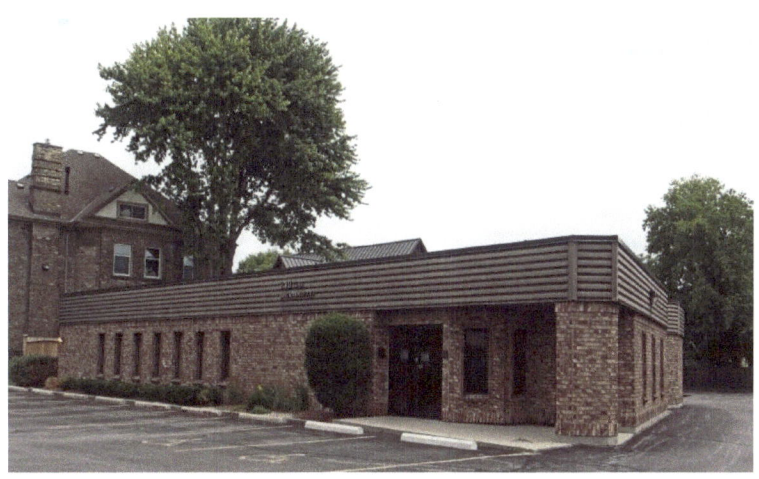

230 Vidal Street North - 1903

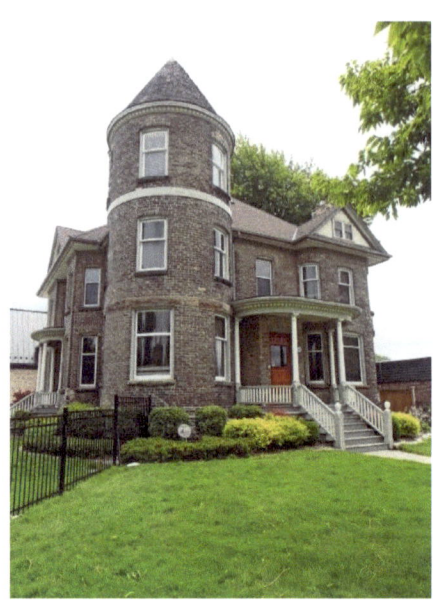

240 Vidal Street North – 1900 – Victorian - 3-storey tower with conical roof covered with cedar shingles, fish scale patterning in gable

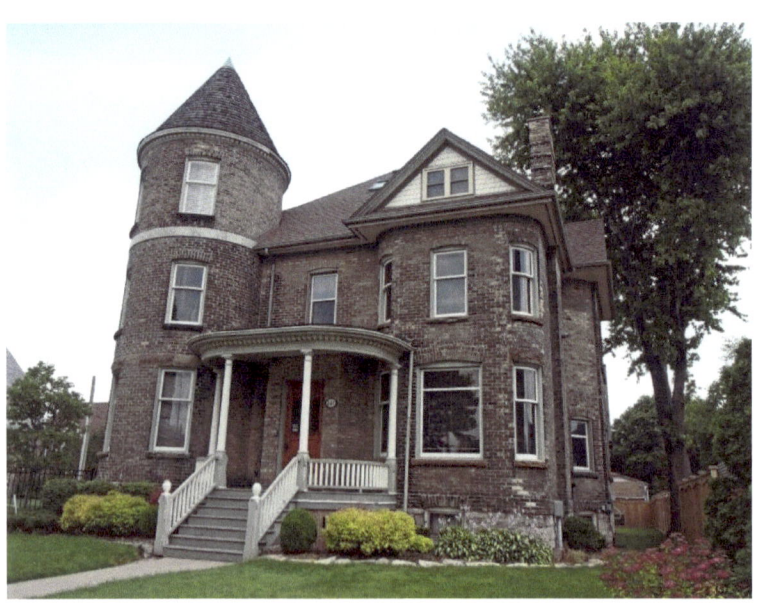

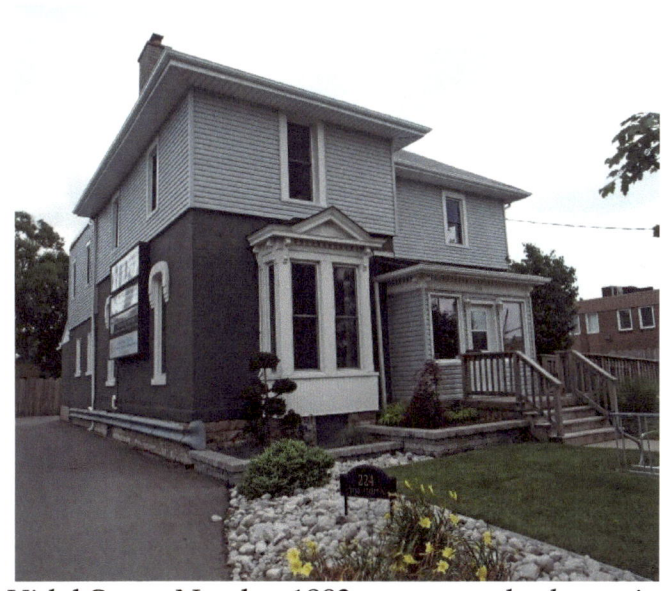

224 Vidal Street North – 1893 – rectangular bay window with pediment

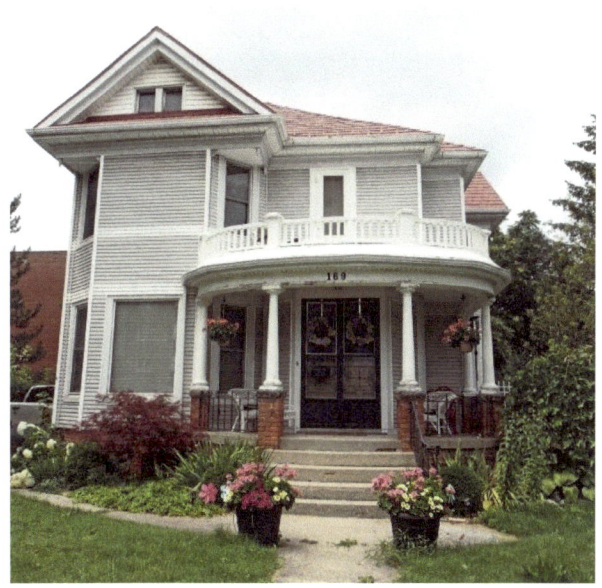

169 Vidal Street South – 1900 – Edwardian – semi-circular verandah with second floor balcony

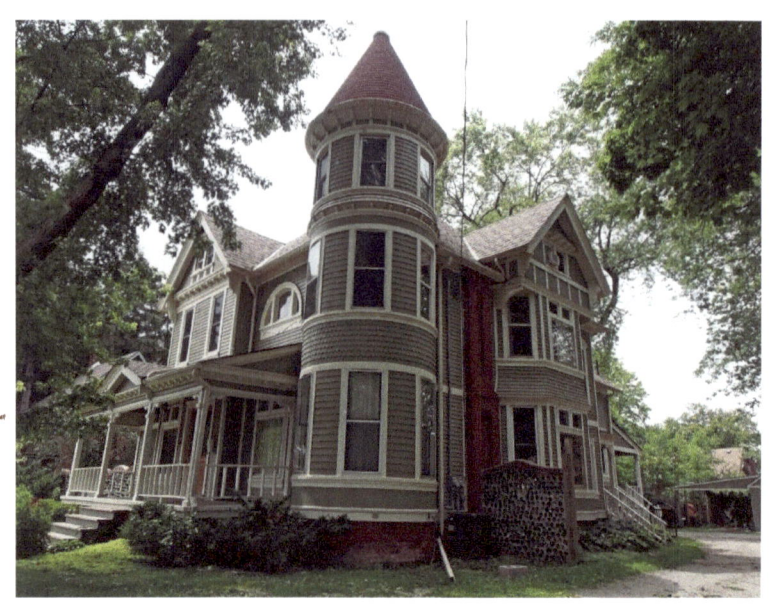

183 Vidal Street South – Queen Anne – three-storey turret with cone shaped roof

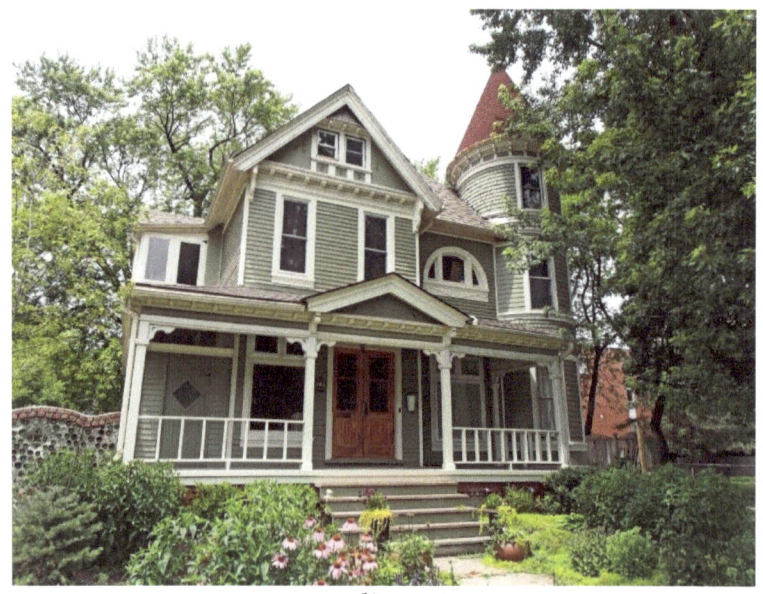

pediment

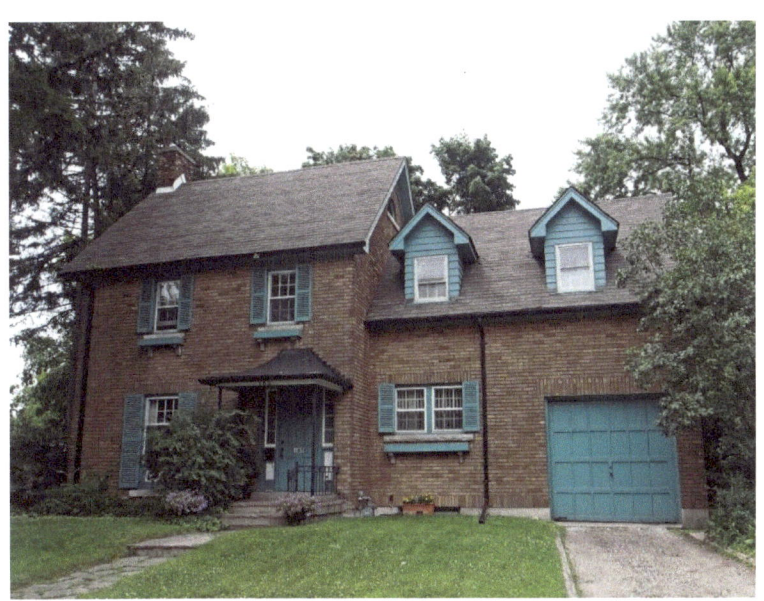

185 Vidal Street South – 1938 – Gothic - dormers

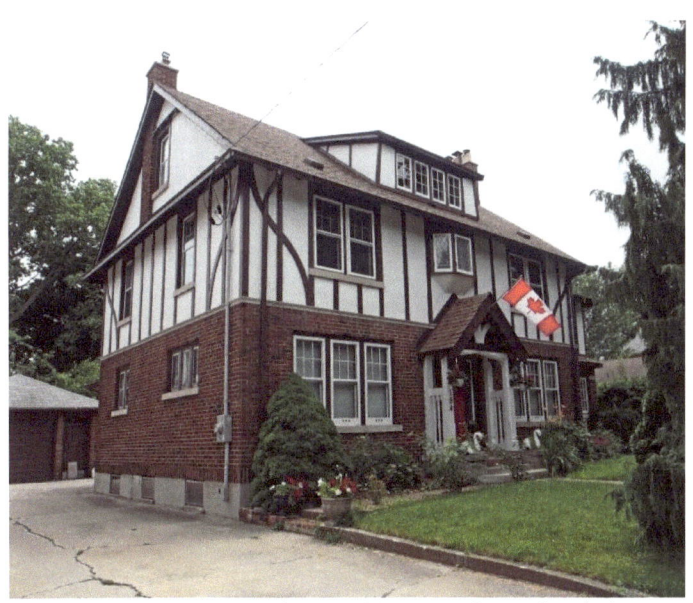

184 Vidal Street South – 1923 – Tudor, shed dormer

200 Vidal Street South – Edwardian – board and batten

Dormer

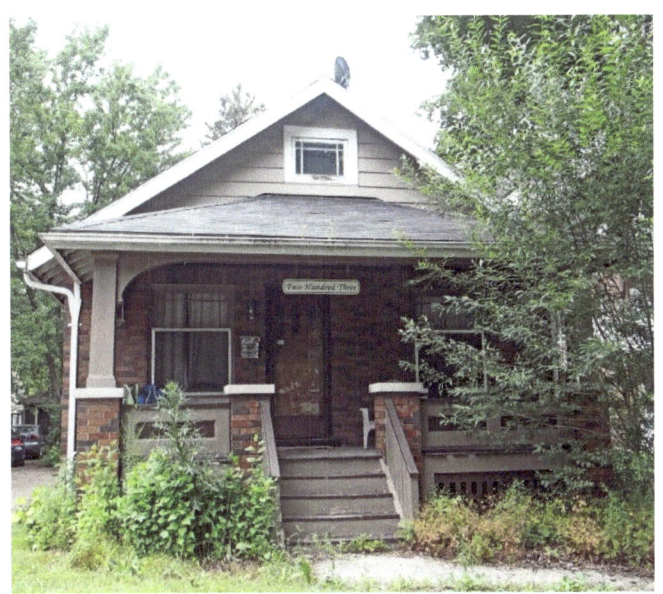

203 Vidal Street South

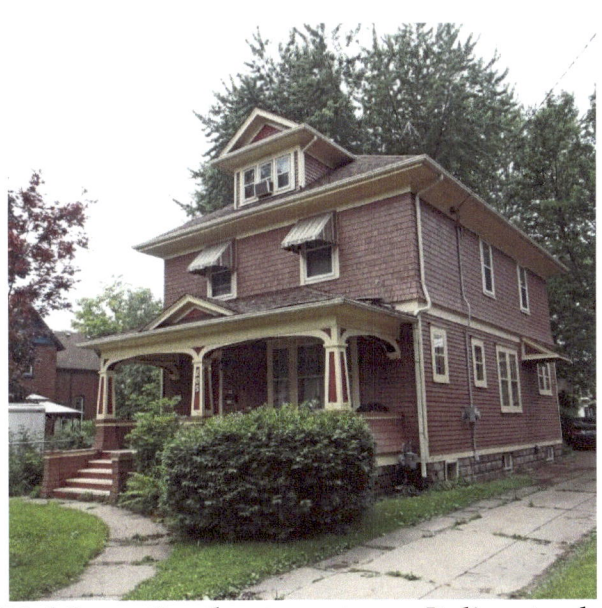

205 Vidal Street South – two-storey, Italianate, dormer, pediment

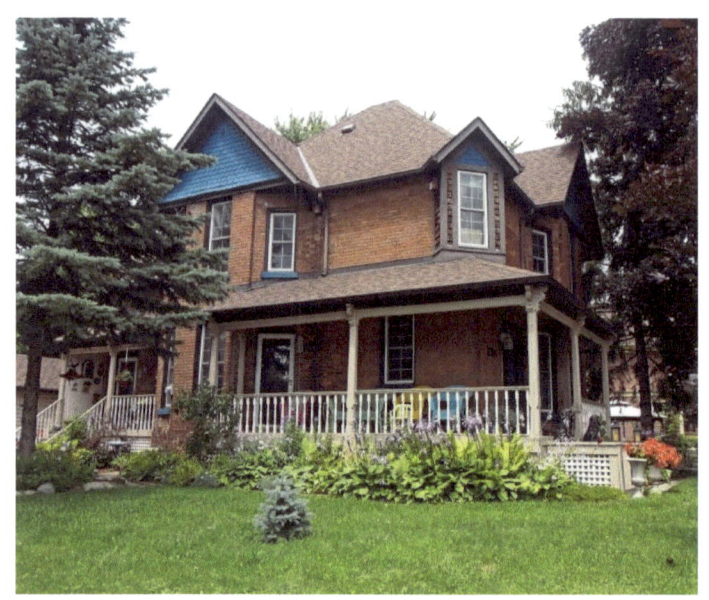

213 Vidal Street South

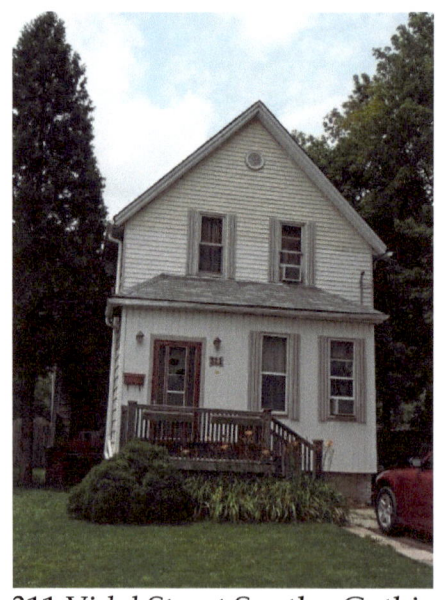

311 Vidal Street South - Gothic

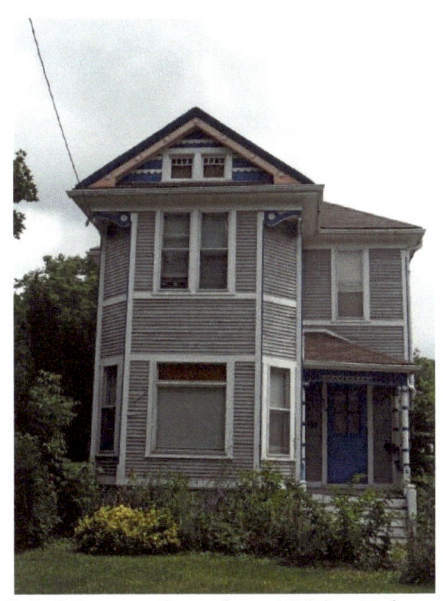

312 Vidal Street South – 1900 - Edwardian

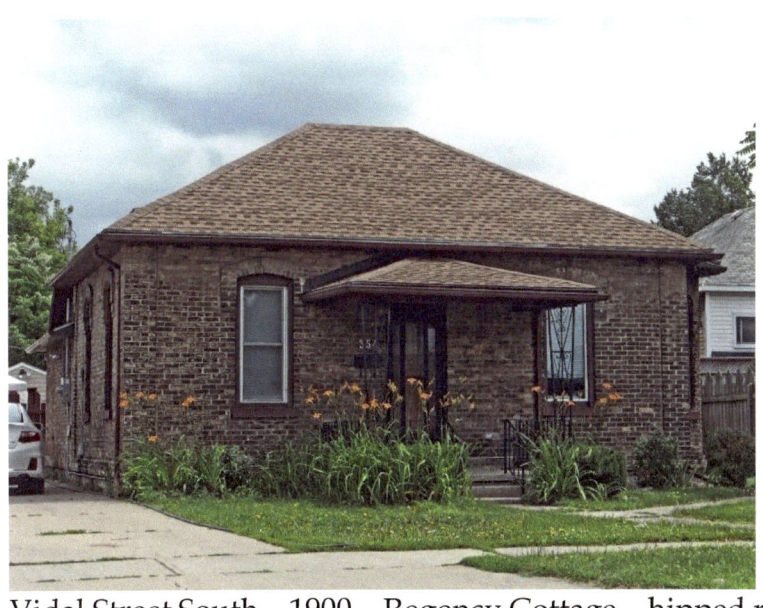

354 Vidal Street South – 1900 – Regency Cottage – hipped roof

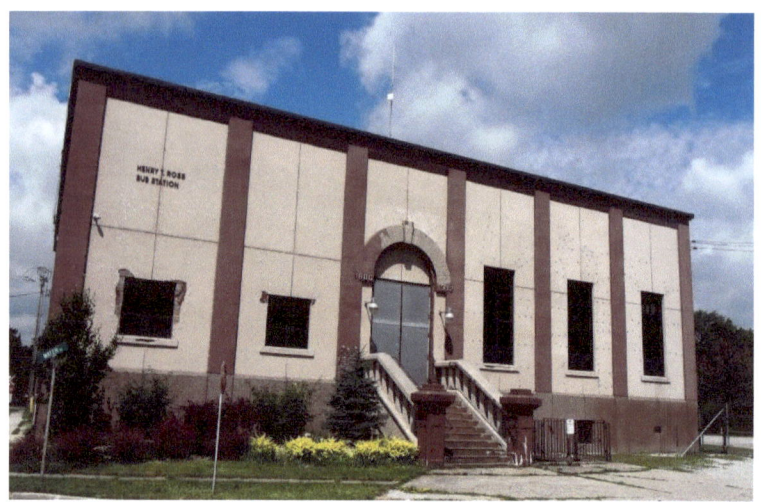

Water Street – Henry T. Ross Sub Station – 1880-1912
Voussoir and keystone

159 Watson Street – Mansard roof, corner quoins

158 Watson Street – 1940 – Arts and Crafts

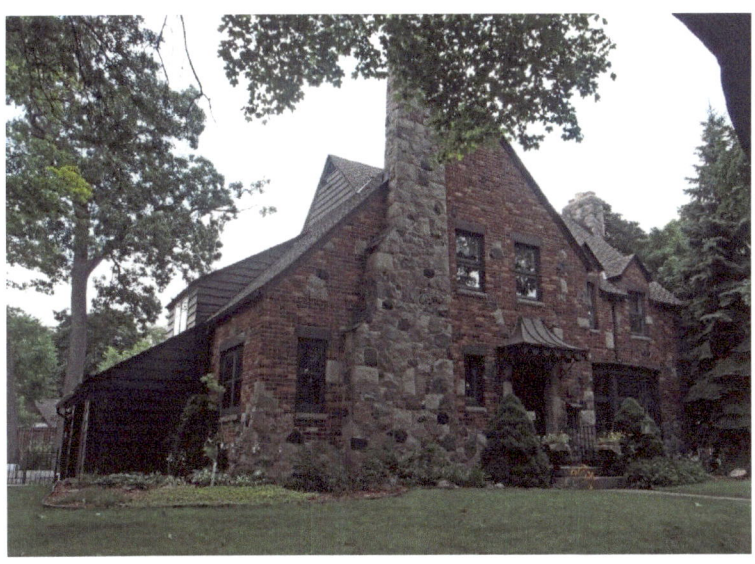

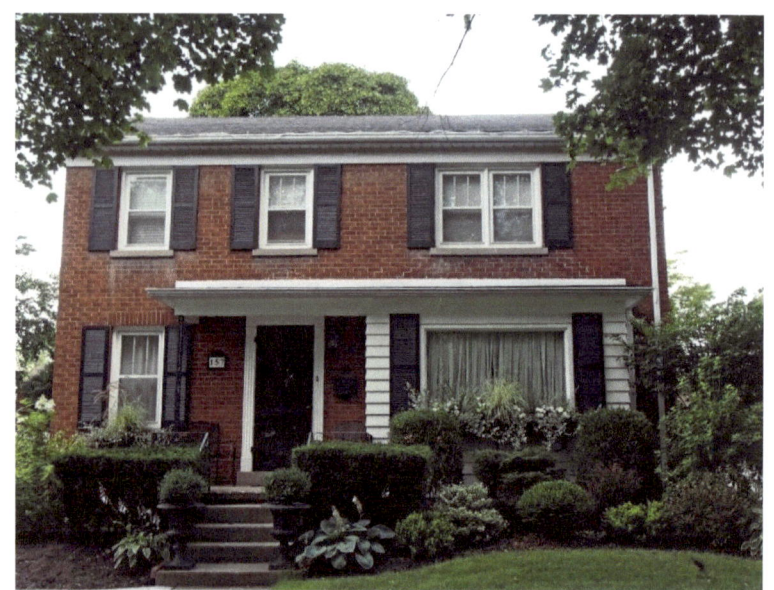

157 Watson Street

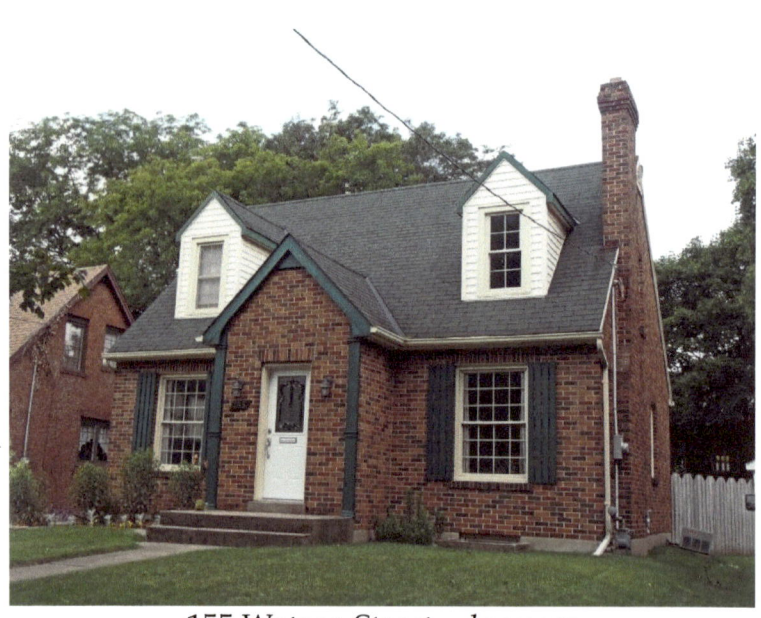

155 Watson Street - dormers

153 Watson Street - vernacular

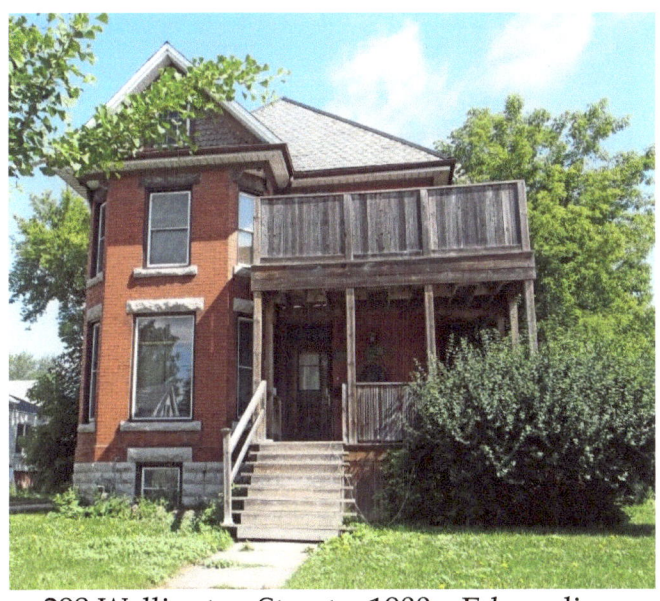

298 Wellington Street – 1900 – Edwardian, second floor balcony

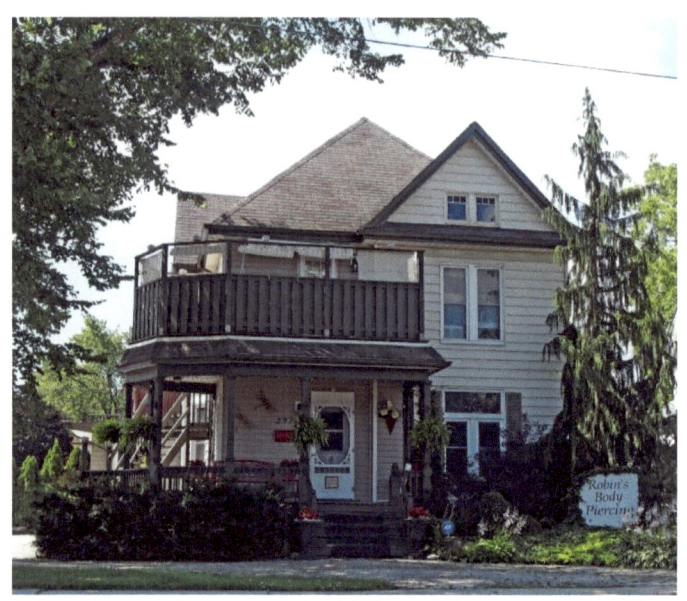

297 Wellington Street – Edwardian – two-storey wraparound verandah

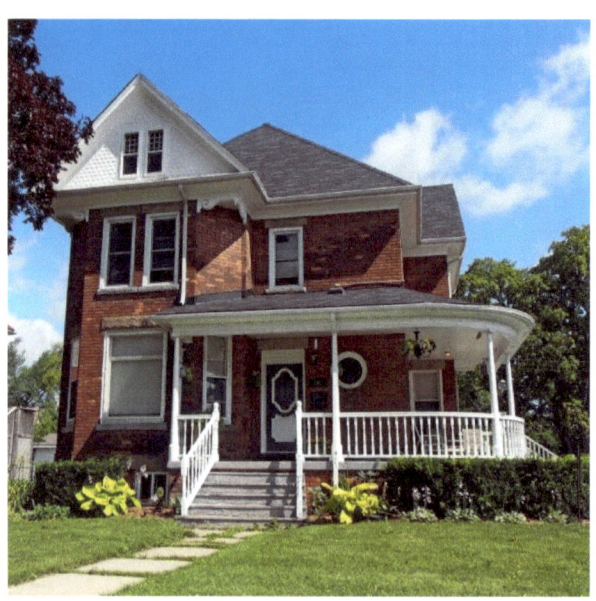

282 Wellington Street – 1900 – Edwardian, wraparound verandah

275 Wellington Street

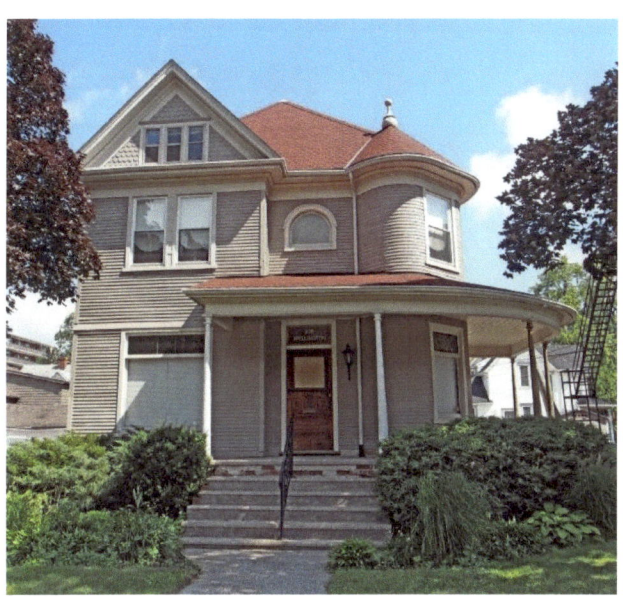

276 Wellington Street – 1900 – Queen Anne – turret, wraparound verandah

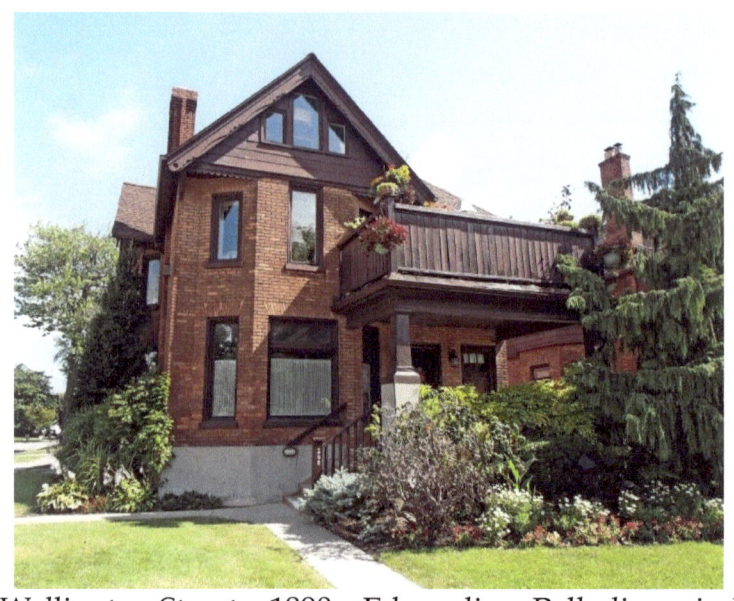

268 Wellington Street – 1890 – Edwardian, Palladian window, second floor balcony

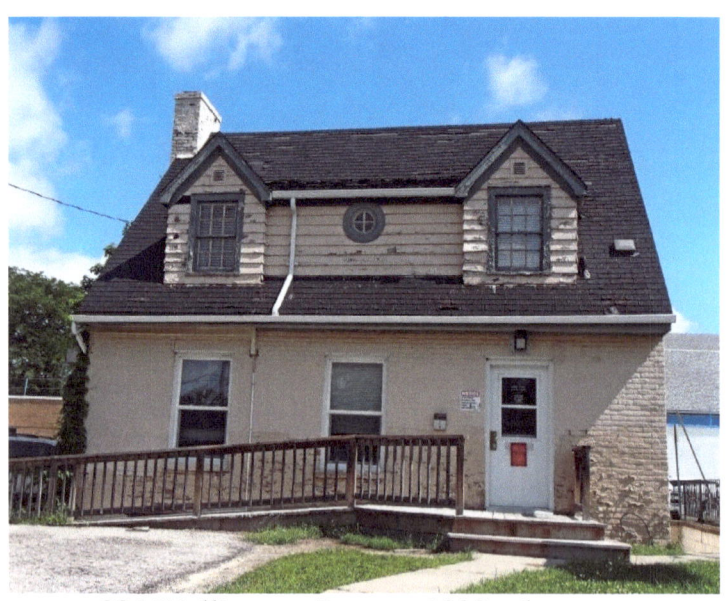

226 Wellington Street – 1938 - dormers

Point Edward, Ontario

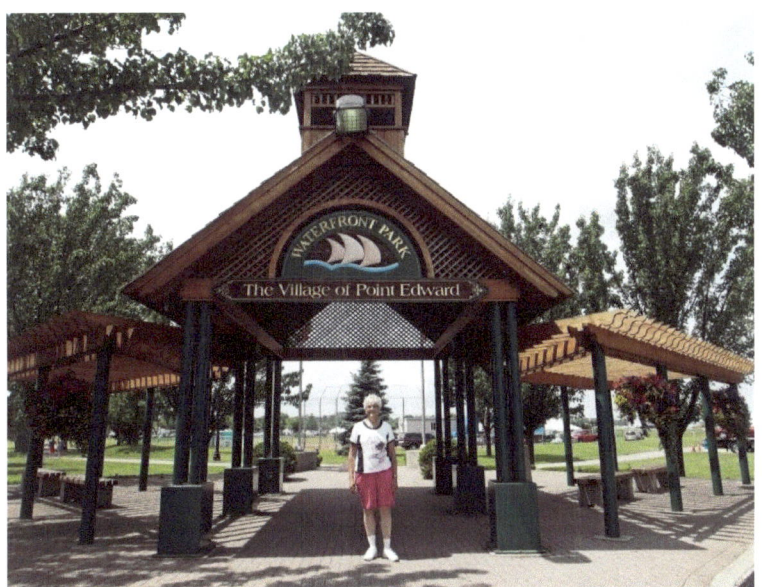

The Village of Point Edward Waterfront Park

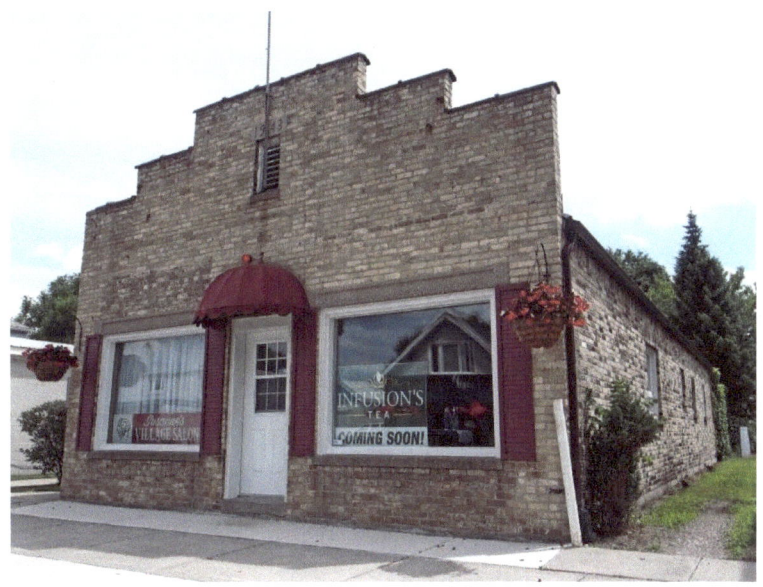

Jacobean Gable

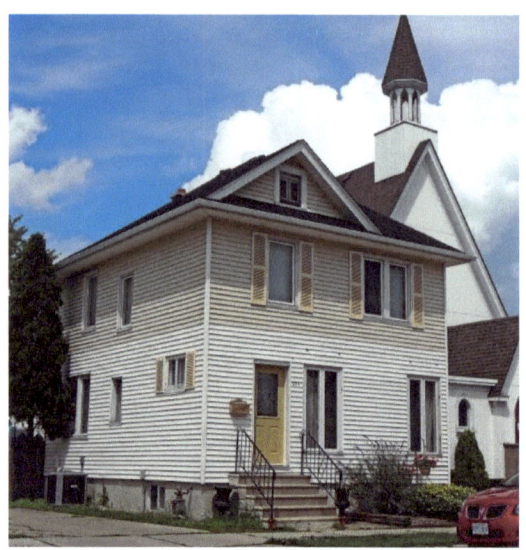
Two-storey house beside the church

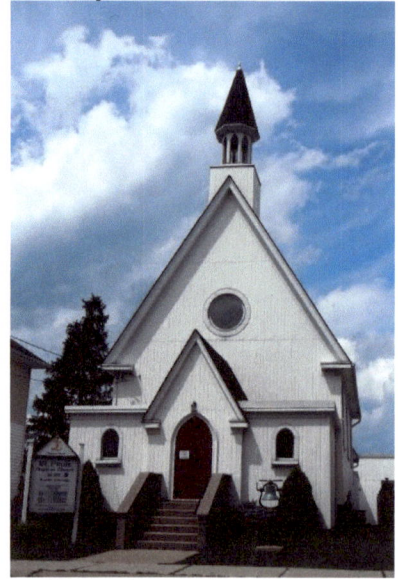
St. Paul's Anglican Church establish 1868

210 Michigan Avenue - From 1868 until 1902 when the church stood at the corner of Livingston and Victoria Avenue, the tall steeple with its flashing tin roof, together with the Fort Gratiot Lighthouse, served to guide mariners down-bound on Lake Huron to the channel leading to the St. Clair River. After 1902, the church was moved to its present location on Michigan Avenue by teams of horses.

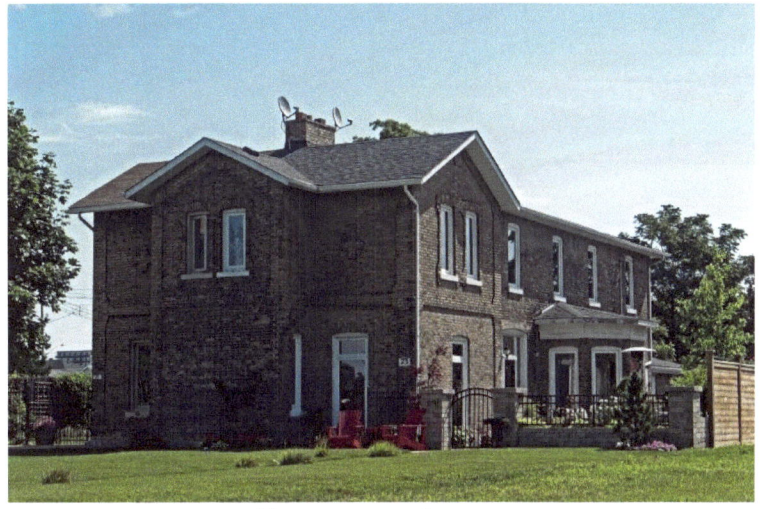

Two-storey house

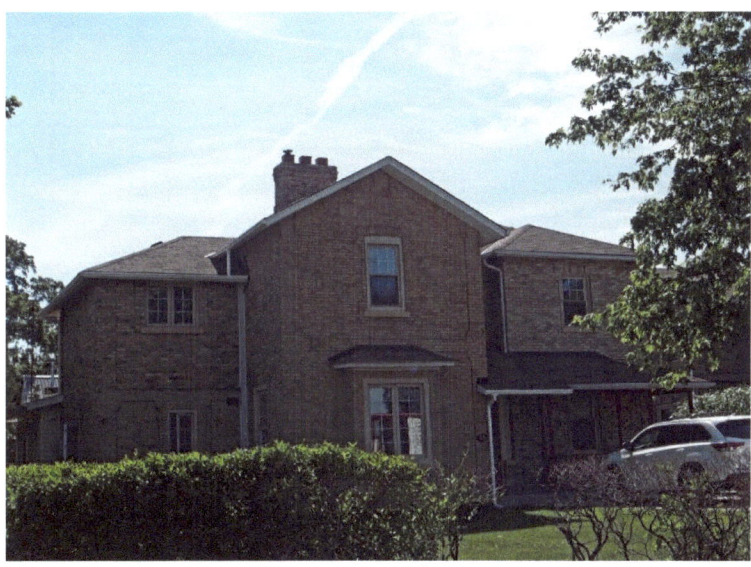

Two-storey house

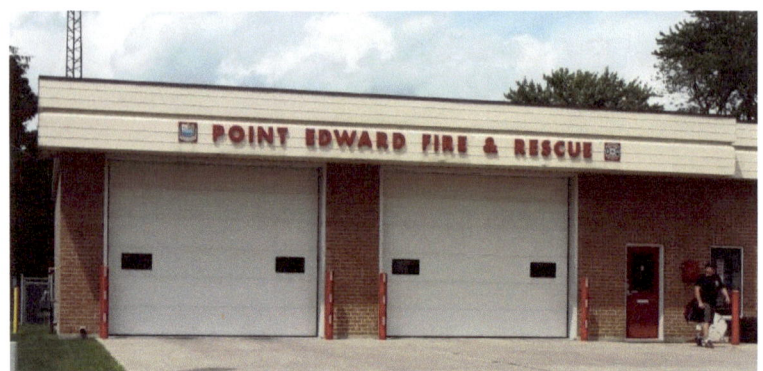

Point Edward Fire Station

#14 - house by John Rigg - established 1895 – Gothic Revival, voussoirs and keystones, transom window

voussoirs and keystones

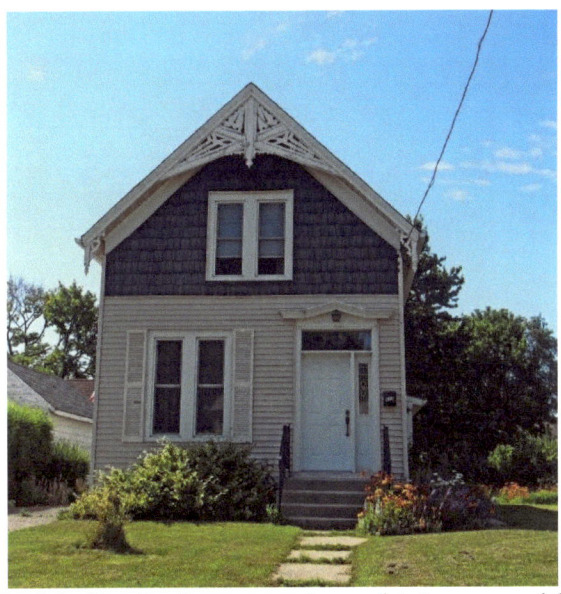

Gothic Revival – verge board trim on gable

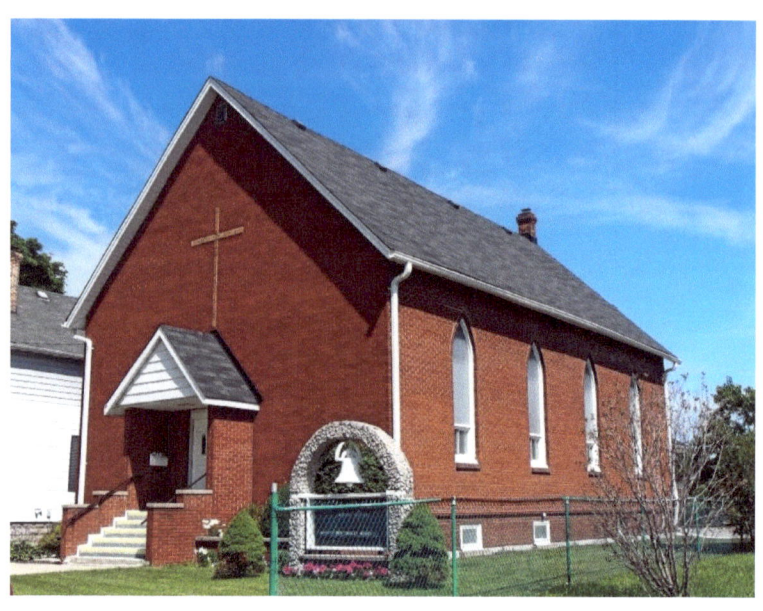

Point Edward Presbyterian Church – Gothic, lancet windows

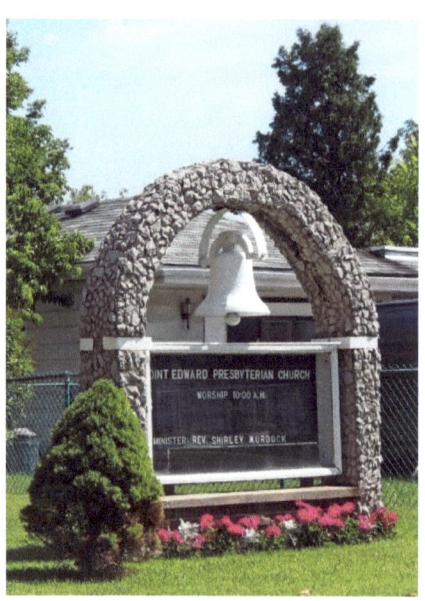

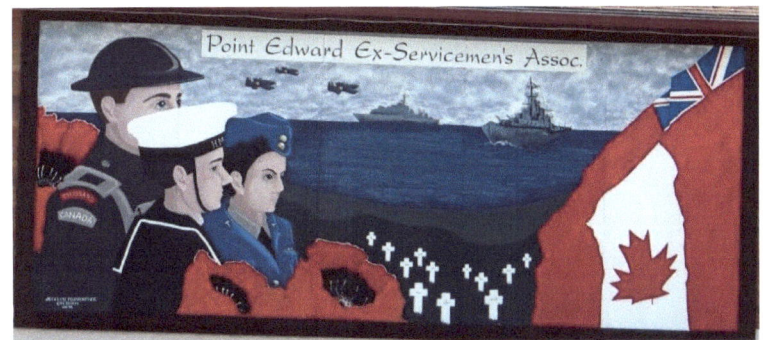

Mural

Point Edward Ex-Servicemen's Association

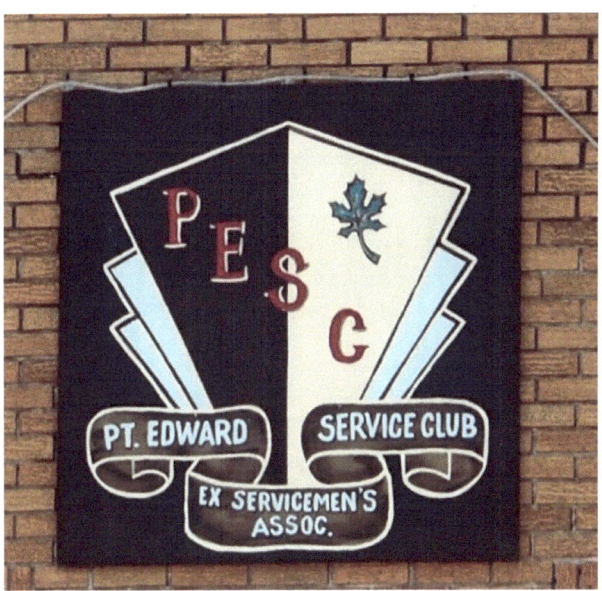

Blue Water Bridge

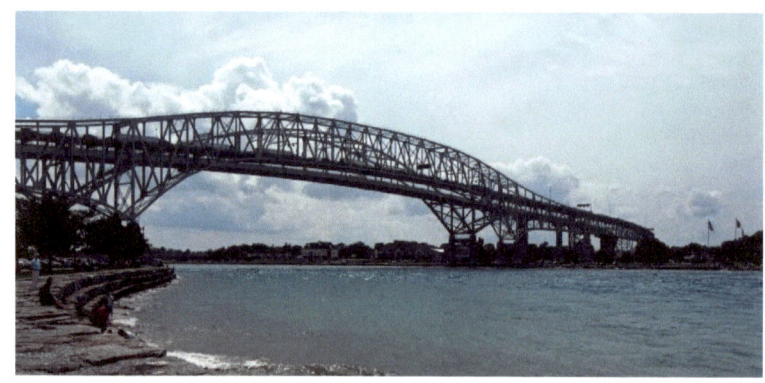

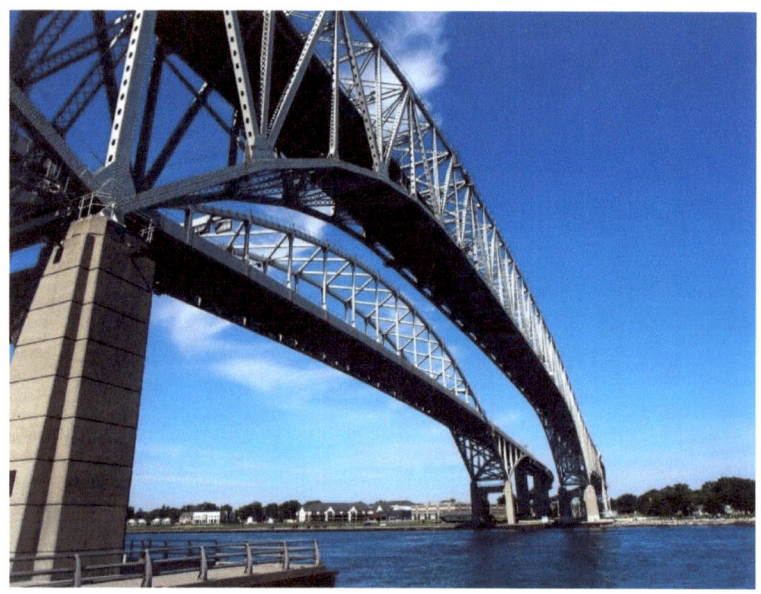

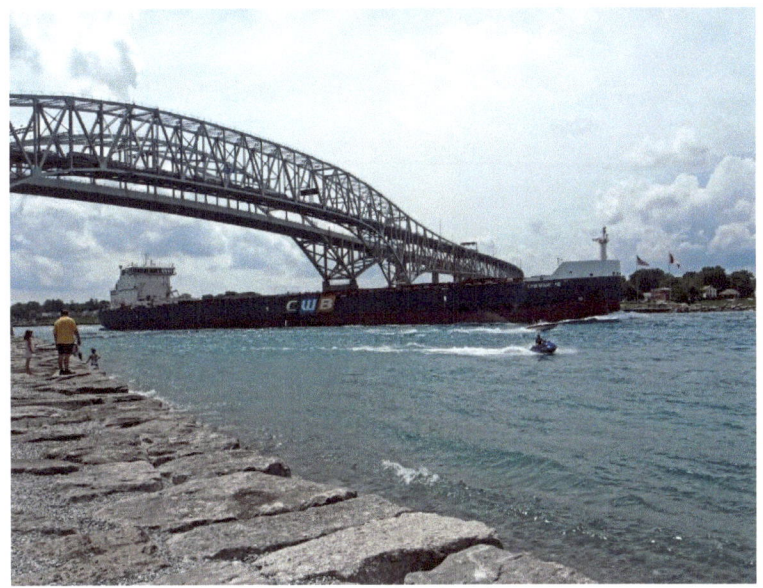

Tanker under bridge

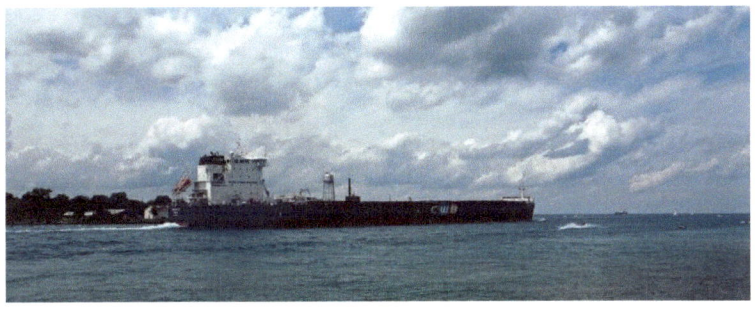

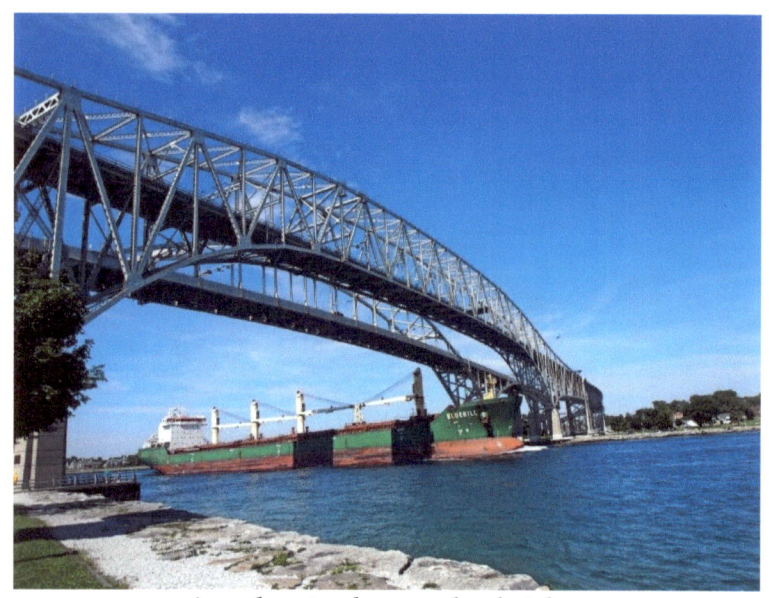
Another tanker under bridge

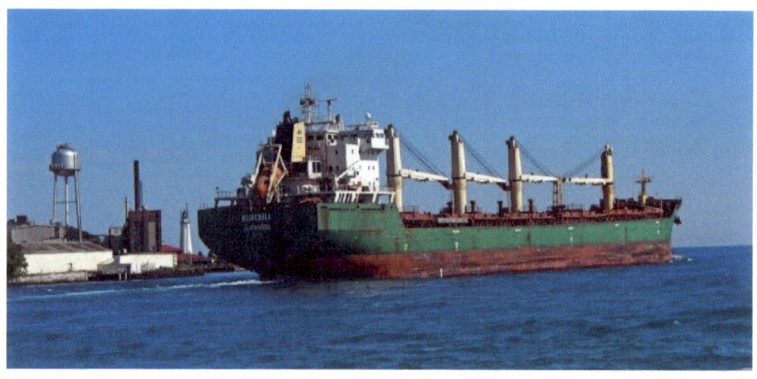

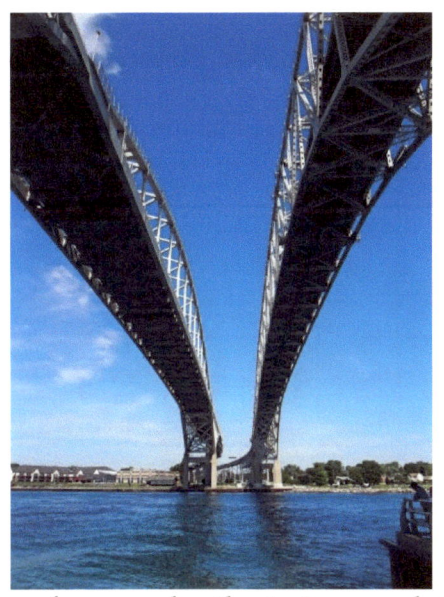

A view from under the twin-span bridge

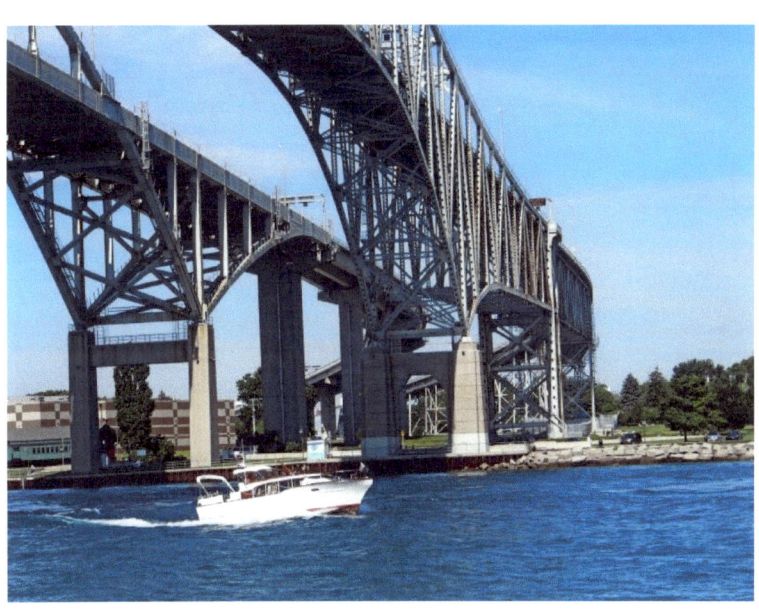

Port Huron, Michigan, U.S.A.

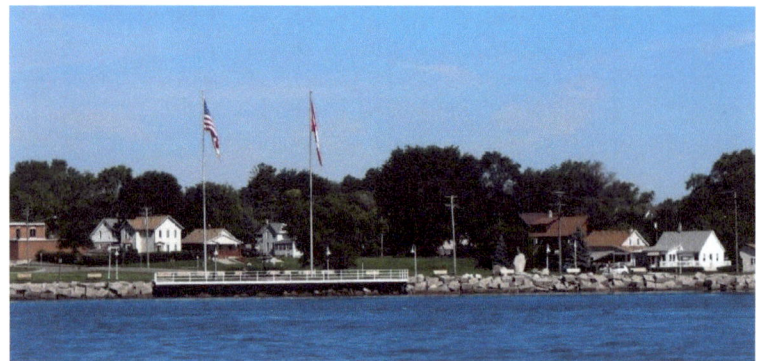

Port Huron

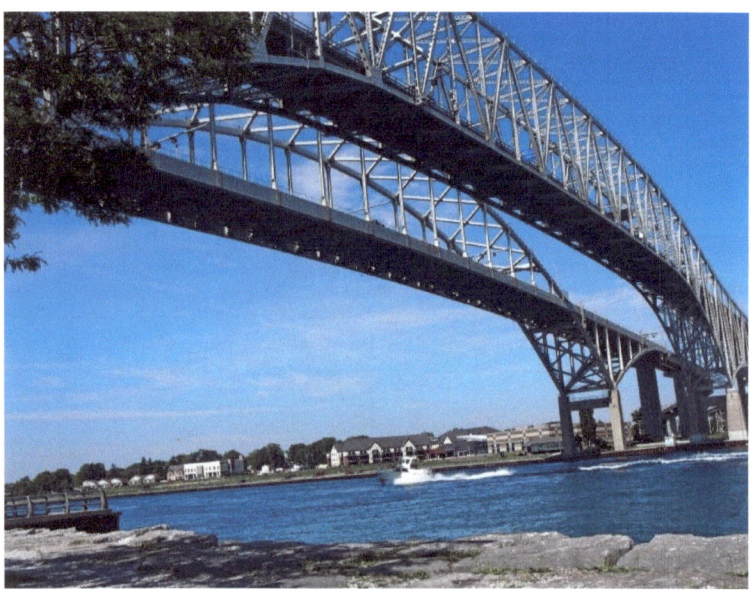

Pleasure boat under bridge – Port Huron in background

Port Huron

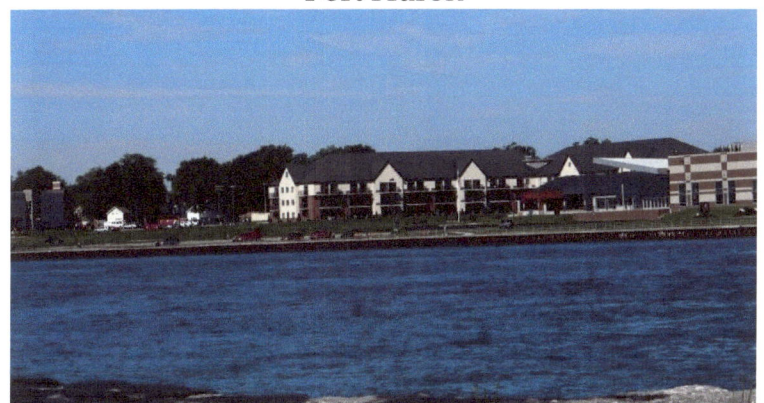

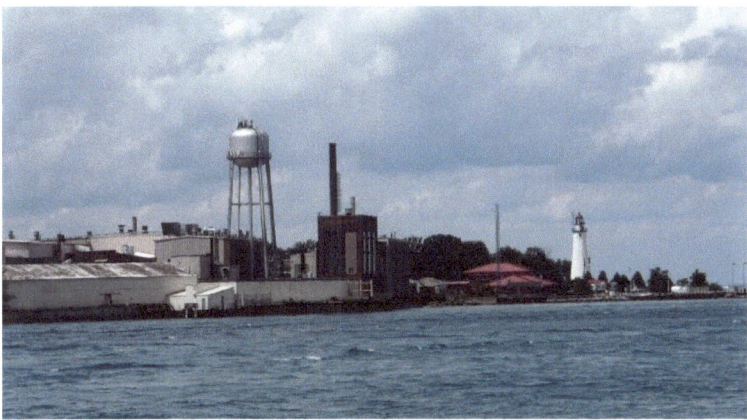

Water Tower and Lighthouse - Port Huron

Architectural Terms

Banding: Different materials, colours or textures used in horizontal bands along a wall. Example: 248 Vidal Street North, Page 22	
Bay Window: A window that projects out from a wall, in a semicircular, rectangular, or polygonal design. Used frequently in Gothic and Victorian designs. Example: 262 Vidal Street North, Page 20	
Brackets: a decorative or weight-bearing structural element which forms a right angle with one side against a wall and the other under a projecting surface such as an eave or roof. Example: 251 Vidal Street North, Page	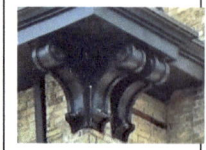
Buttress: a masonry structure built against or projecting from a wall which serves to support or reinforce the wall. In Canadian architecture, they are sometimes used for decoration. Example: 248 Vidal Street North, Page 22	
Cornice: originally the wooden overhang of the roof. With the use of stone, brick, iron and steel, the cornice is any projecting shelf at the top of a ceiling or roof. They can be very decorative. Example: 314 Vidal Street North, Page 9	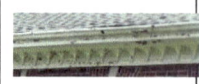

Cornice Return: decorative element on the end of a gable. Example: 329 Vidal Street North, Page 12	
Dentil Moulding: an even series of rectangles used as ornamental decoration in cornices. Example: 134 Victoria Street, Page 6	
Dormer: (French for "sleep") a gable end window that pierces through the plane of a sloping roof surface to create usable space in the top floor or attic of a building by adding headroom. Example: 320 Vidal Street North, Page 20	
Entrance: The entrance encompasses the doorway and the inner vestibule or, in residential architecture, the covered porch. Example: 314 Vidal Street North, Page 9	
Gable: the triangular portion of a wall between the edges of a sloping roof. Example: 280 Vidal Street North, Page 16 **Jacobean Gable:** the gable extends above the roofline. Example: 262 Vidal Street North, Page 20	

Hipped Roof: a roof where all sides slope downwards to the walls with no gables. Example: 354 Vidal Street South, Page 31	
Keystones and Voussoirs: a voussoir is a wedge-shaped element used in building an arch. A keystone is the central stone that locks all the stones into position, allowing the arch to bear weight. A keystone is often enlarged and embellished. Example: Water Street, Page 32	
Lancet Window: a tall, narrow window with a pointed arch at its top. Example: 248 Vidal Street North, Page 22	
Mansard Roof: This style was popularized by Francois Mansart (1598-1666), an accomplished architect of the French Baroque period and especially fashionable during the Second French Empire (1852-1870). This roof is almost flat on the top section, with two slopes on each of its sides with the lower slope at a steeper angle than the upper and having dormer windows. Example: 159 Watson Street, Page 32	
Palladian Window: a large window that is divided into three sections with the centre section larger than the two side sections and usually arched. Example: 268 Wellington Street, Page 38	

Pediment: a triangular section above the horizontal structure (entablature), typically supported by columns. The inside of the triangle is called the tympanum. Example: 319 Vidal Street North, Page 11	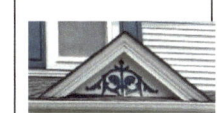
Quoin: masonry blocks at the corner of a wall, often a decorative feature, usually larger or of a different colour than the rest of the wall. Example: 159 Watson Street, Page 32	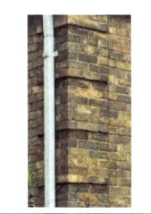
Sidelight: a window, usually with a vertical emphasis, that flanks a door, and is often used to emphasize the importance of a primary entrance. **Transom Window:** the light above the doorway, also called a fanlight. Example: 314 Vidal Street North, Page 9	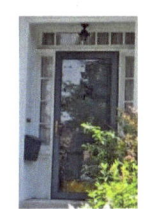
Turret: a small tower that projects from the wall of a building. Example: 183 Vidal Street South, Page 26	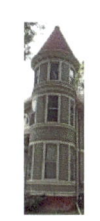
Verge board and Finial: also called bargeboards – hang from the projecting end of a roof and are often elaborately carved and ornamented. **Finial:** ornament added to the top of a gable, pinnacle, canopy or spire – a Gothic element. Example: Point Edward, Page 43	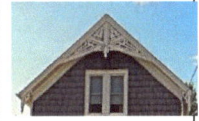

Building Styles

Arts and Crafts: The overlying theme - the house was based on the function of the house. Rooms were oriented to take advantage of the movement of the sun for warmth and light during daylight hours. Side entrances allowed for useable space on the front facade for light or garden use. Arts and Crafts houses have many of these features: wood, stone or stucco siding; low-pitched roof; wide eaves with triangular brackets; exposed roof rafters; porch with thick square or round columns; stone porch supports; exterior chimney made with stone; open floor plans with few hallways; many windows, some with stained or leaded glass; beamed ceilings; dark wood wainscoting and moldings; built-in cabinets, shelves, and seating. Example: 158 Watson Street, Page 33	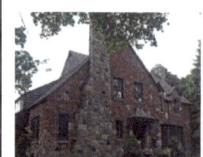
Edwardian, 1900-1930 – This style bridges the ornate and elaborate styles of the Victorian era and the simplified styles of the 20th century. Balanced facades, simple roof lines, dormer windows, large front porches, and smooth brick surfaces are its characteristics. Example: 286 Vidal Street North, Page 17	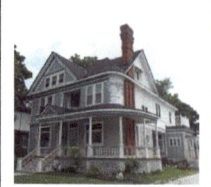
Georgian, before 1860 – This style began with the British King Georges in the 18th century. These buildings have balanced facades around a central door, medium-pitched gable roofs, and small paned windows. Example: 314 Vidal Street North, Page 9	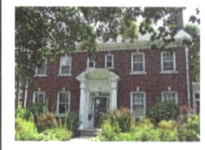

Gothic Revival, 1830-1890 – These decorative buildings have sharply-pitched gables with highly detailed verge boards, pointed-arch window openings, and dichromatic brickwork. It is a common style in Ontario. Example: #14, Point Edward, Page 42	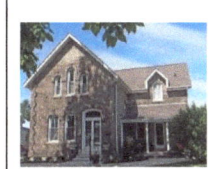
Italianate, 1850-1900 – It has wide-bracketed eaves, belvederes, wrap-around verandahs. Example: Vidal Street North, Page 11	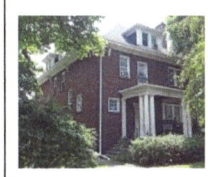
Queen Anne, 1885-1900 – This style is distinguished by an irregular outline featuring a combination of an offset tower, broad gables, projecting two-storey bays, verandahs, multi-sloped roofs, and tall, decorative chimneys. A mixture of brick and wood is common. Windows often have one large single-paned bottom sash and small panes in the upper sash. Example: 183 Vidal Street South, Page 26	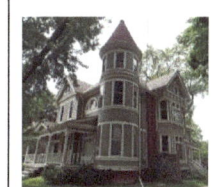
Regency Cottage, 1830-1860 – This style originated in England in 1815 and spread to Ontario later in the 19th century as British officers retired to Canada. It is a modest one-storey house with a low-pitched hip roof and has a symmetrical front façade. Example: 354 Vidal Street South, Page 31	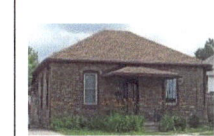

Second Empire, 1860-1880 – The mansard roof is the most noteworthy feature of this style and is evidence of the French origins. Projecting central towers and one or two-storey bays can also be present. Example: 159 Watson Street, Page 32	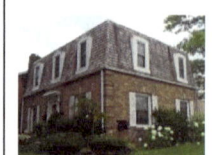
Tudor Revival – exposed timbers with stucco infill, multi-paned windows. Example: 184 Vidal Street South, Page	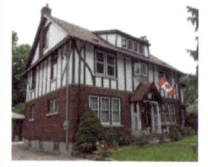
Vernacular/Traditional Mode 1638 - 1950 Influenced but not defined by a particular style, vernacular buildings are made from easily available materials and exhibit local design characteristics. Example: 329 Vidal Street North, Page 12	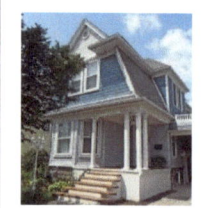
Victorian - In Ontario, a Victorian style building can be seen as any building built between 1840 and 1900 that doesn't fit into any of the other categories. It encompasses a large group of buildings constructed in brick, stone, and timber, using an eclectic mixture of Classical and Gothic motifs. Example: 240 Vidal Street North, Page 24	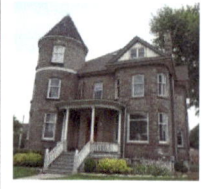

www.ingramcontent.com/pod-product-compliance
Lightning Source LLC
Chambersburg PA
CBHW040852180526
45159CB00001B/406